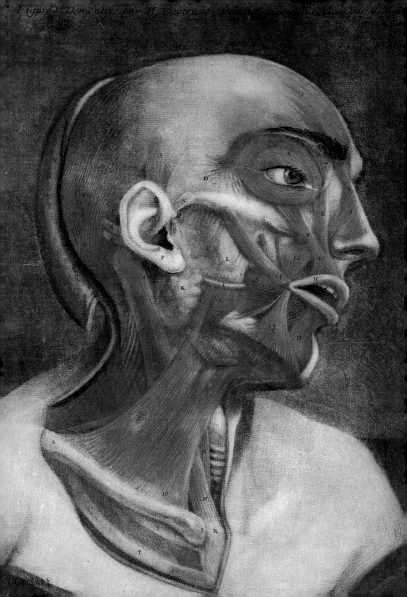

Figure 1 Demontrée par M. Duvernay,

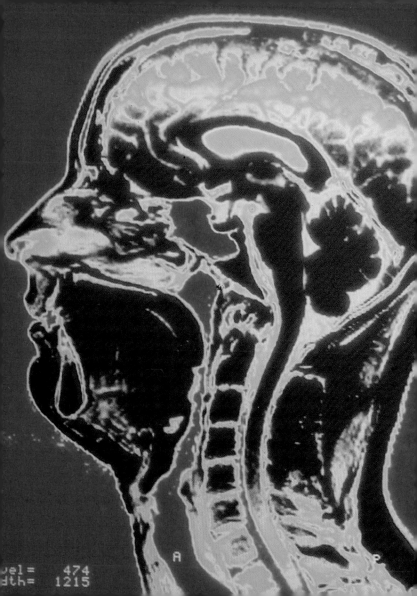

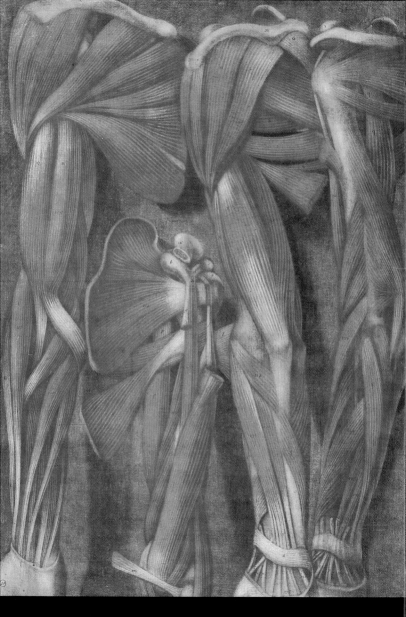

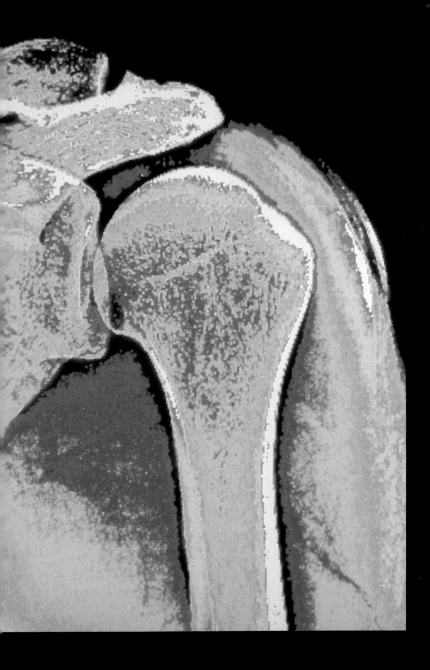

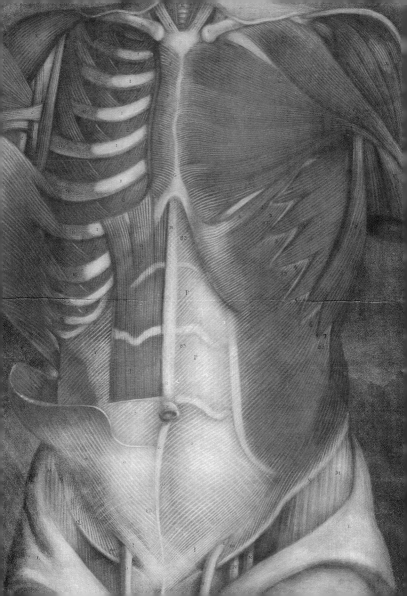

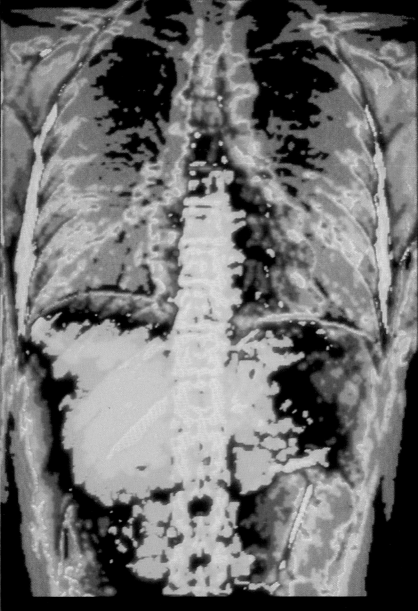

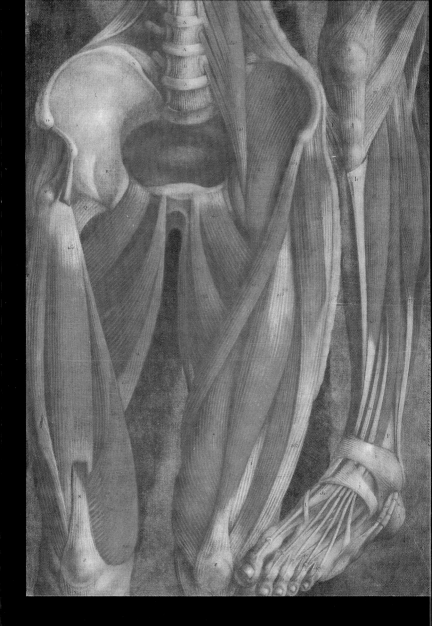

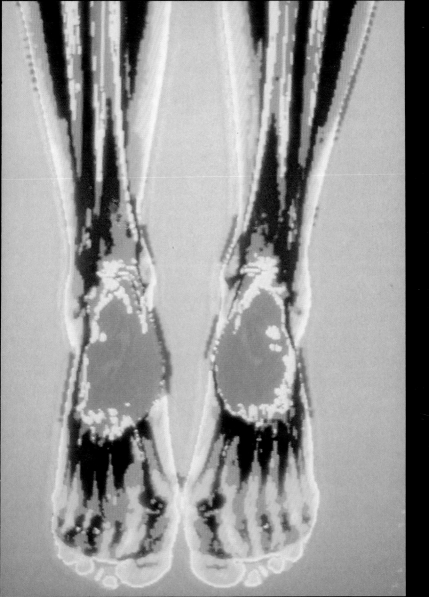

CONTENTS

1 THE IDEAL BODY
13

2 THE OUTRAGED BODY
39

3 AT THE HEART OF THE BODY
65

4 AUTOMATED BODIES
93

5 EMBODYING DESIRE
111

DOCUMENTS
129

Further Reading
154

List of Illustrations
154

Index
158

IMAGES OF THE BODY

Philippe Comar

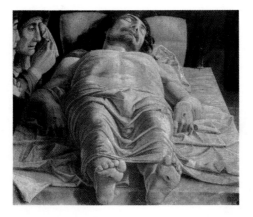

DISCOVERIES®

HARRY N. ABRAMS, INC., PUBLISHERS

"The lovely young women you've seen at Nîmes cannot have delighted your spirit any less, I am sure, than the beautiful columns of the [ancient Roman] Maison Carrée, which, after all, are but antique copies of these very women."

Nicolas Poussin (1594–1665),
letter to Paul Fréart,
Sieur de Chantelou (1609–94),
20 March 1642

CHAPTER 1
THE IDEAL BODY

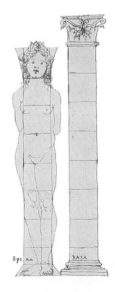

Left: the *Aphrodite of Cyrene,* a 2d-century BC Greek sculpture whose elegant proportions are much admired. Right: a Renaissance artist compares the human figure to a column. Many viewers have seen the perfection of certain architectural forms as a reflection of human proportions. In a dialogue by the French poet Paul Valéry (1871–1945), the architect Eupalinos reveals the secret of the temple he built to Hermes: "This delicate temple, unbeknownst to everyone, is the mathematical image of a young woman of Corinth, whom I had the good fortune to love. It faithfully duplicates those particular proportions."

When we create depictions of the human body, we often have a strange way of perceiving it: our self-images are capricious and unstable; we are always ready to reconsider and reevaluate ourselves. Why are the ways in which we represent ourselves so changeable, metamorphosing from one form to another? Are all appearances trustworthy? Does an artist, transposing an image of him- or herself onto a piece of paper or into a block of marble, reshape that self-image?

In the modern era, images of the body have proliferated; we routinely see it represented accurately and in distortion, drawn and photographed, in every posture and context, embellished, powdered, and painted, magnified and denigrated, sometimes bruised or mutilated. Do we even know why we struggle so to depict it?

The body stands upright

Some 30,000 years ago human beings first sketched out their own images in three dimensions, carving figurines and, later, erecting monoliths and driving stakes into the ground, on which they carved faces. This was a way to represent the human form standing, struggling against gravity to attain the posture that distinguishes us from

The earliest type of anthropomorphic idol mentioned in ancient Greek literature is the *xoanon,* a wooden statue cut from a beam or block, with a very simple form: a stiff, vertical body with arms and legs attached. Below: this 7th-century BC figure of a female deity, possibly Artemis, is of a later but similar type, made of bronze plates over a wooden core. The pose is formal and hieratic, with the lower body enclosed in a rigid sleeve. Statues of female figures long retained this cylindrical aspect. Left: a *kore,* or female goddess figure, of the 6th century BC, representing the goddess Hera (the head is missing).

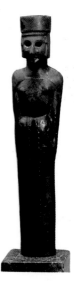

the other animal species. We consolidate the image of our own stature in that most human of concepts, the statue. Neolithic standing stones, menhirs, pillars, and stelae are early affirmations of this upright posture, which defines humankind's quest, physical and mental, for verticality. A century before Christ, the Roman architect Vitruvius (1st century BC) stressed the anthropomorphic nature of Classical columns, derived from the ancient Greeks: "The Greeks," he wrote, "formed the Doric column according to the proportions, the strength, and the beauty of the male body...They gave the Ionic column the delicacy of the female."

The basic principles of architecture rely on a system of proportions and symmetry borrowed directly from, and relating to, the human form. As has often been remarked, architecture is thus dependent on the body. This dependence reflects our desire to harmonize the material world offered to our senses in all its complexity with the pure forms distilled by the mind. The Classical architectural column refers to the essential lines of the human body, standing straight and elegant as the letter I.

This extreme simplification of the living form, metamorphosed here into a geometric solid, implies that every form potentially contains the idea of a perfect model.

A concept of the ideal begins with the rejection of appearances and the quest for a more profound identity concealed beneath particularities. In notes relating to his painting *L'Age d'or* (*The Golden Age*), the French Neoclassical painter Jean-Auguste-Dominique Ingres (1780–1867) writes that one must not be too attached to the details of the human body, but ought rather to seize the essential by substituting simple geometric shapes for the complex contours of the living being. Below: a Renaissance drawing by Luca Cambiaso from about 1550 breaks the body down into faceted geometric solids.

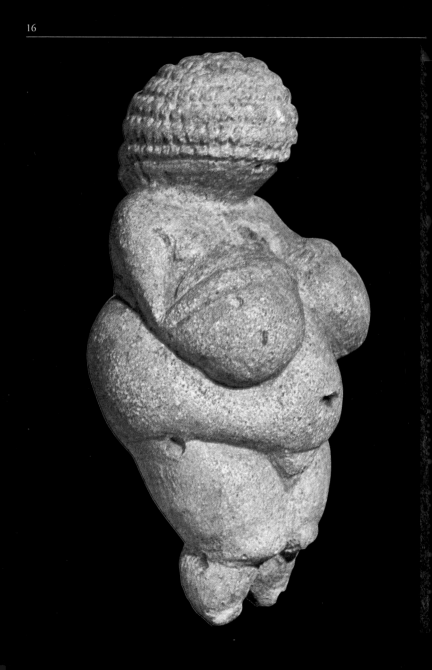

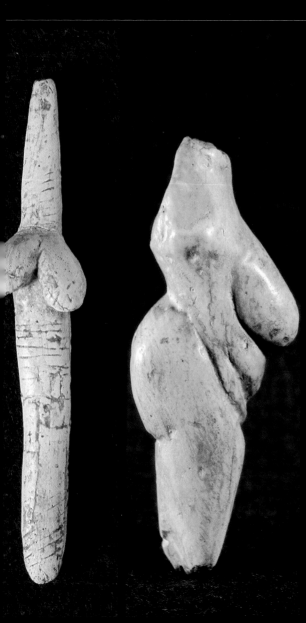

Shaped in the hollow of the hand nearly 30,000 years ago, these prehistoric statuettes are scarcely larger than a peach stone. Their forms are highly stylized and probably symbolic, with the breasts exaggeratedly large; it is thought that these figurines were associated with fertility rites or a fertility cult. In some, the upper and lower parts of the body present a disturbing symmetry. Their small feet suggest that they were intended to be held or driven like little stakes into the earth, rather than placed on a pedestal. Somewhat like the painters of images on the walls of palaeolithic caves, who incorporated the surface irregularities of the rock into their scenes, early sculptors took advantage of the natural shapes of their materials, exploiting nodules of limestone, forked branches, or the tuberous qualities of bones.

When we criticize these bodies, when we judge the length of a neck, the convex arc of a back, the breadth of a chest, finding excess here and insufficiency there, we are implicitly accepting the existence of an ideal body. But by what standards do we define it? How has humankind, ever since early antiquity, apprehended and taken into account the proportions of the body?

In ancient Egypt: an unequivocal body

Ancient Egyptian mural paintings and bas-reliefs focus on figures of the human body, which they put through strange gymnastics: the head and limbs are seen in strict profile, while the upper torso and shoulders are viewed frontally. Why this contortion? Presumably Egypt's skilled artists were capable of drawing a foot viewed from the front, but had reasons to favor the profile. Egyptian wall paintings and friezes tell stories and illustrate chronicles, using codes and rules for which modern viewers require instructions, if they are to be deciphered properly. Each figure refers to another; the orientation of the legs and feet indicates the direction that the eye is to follow. For the Egyptians, perspectival depth in painting is a sign of equivocation; it supposes a doubling of the senses or the superimposition of several stories. Thus the compression of the torso in frontal view, its submission to the picture surface, corresponds to a desire to present the body clearly and fully.

This way of depicting the body, which we consider unrealistic because of its impossible contortions, seemed true to the Egyptians for the very reasons it seems false to

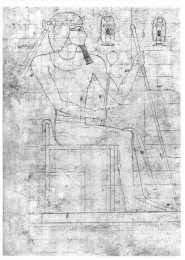

In Egyptian painting, bodily proportions and postures were determined by a formal structural grid. Above: an 18th-Dynasty drawing. Actions were rendered by stereotyped postures and gestures. It was understood, for instance, that to represent a person advancing at a rapid pace, the angle of the legs was double that of a figure standing still. Below: farmers in a mural painting, c. 1450 BC.

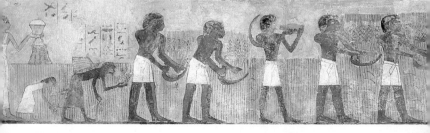

us. Like them, we measure fidelity and accuracy according to conventions. But our conventions today are those of photography, which emphasizes the illusion of depth. The photograph subordinates all other aspects of the image, especially the picture plane, which has its own reality. An Egyptian painter would no doubt have found it a serious betrayal of truth to make a painting pass for something other than what it was: a flat surface.

A body conceived on the scale of eternity

Egyptian mural art shows a remarkable continuity over 2,000 years of history, from the Old Kingdom (c. 2613–2160 BC) to the Late Period (661–332 BC). The Egyptian system of proportions allowed few exceptions and strictly controlled variations. The artist subdivided the surfaces to be painted or sculpted into a fine grid of small squares on which he or she drafted the notable points of the body. This was less a system of measurement, specific to the human form, than a construction plan that provided an inflexible rule for the placement of gestures and the diversity of poses. The human body was subjected to a principle related to that of writing, just as the body of a letter is regulated in calligraphy.

This system of proportions provides a glimpse of the ideal that applied to representation among the Egyptians. Their attention, like their intention, was not directed to the variable and ephemeral aspects associated with human individuality or mortality; rather, they focused on what is permanent and eternal in human beings. In service of that idea, they worked out a matrix common to all bodies. The work of art, rather than striving to simulate life, defined the conditions for its existence in the world to come; it was inscribed within a world of mystical, perfected reality. Once completed, the work of art was symbolically animated by the ceremony known as the "opening of the mouth," a rite that

Left in approximate form, with rough-hewn surfaces, this unfinished Late Period Egyptian statuette still shows traces of the lines of its structural grid. It was never intended as a finished work, but was a model used by artists as a template, to set the proportions of sculptures. It also played a role in the ritual celebrations of Osiris that followed the recession of the Nile waters after the spring floods, marking the onset of the sowing season. It was planted like a seed in the ground; matrix for a work yet to be born, it was a promise of life to come.

infused vital energy into any form intended to be the receptacle of a divine or human spirit. The artist, though restricted to the phase preceding this spiritual birth, thus participated in the mystery of creation. Not insignificantly, the Egyptians called a sculptor "one who shapes life."

From magical to human body

In ancient art, the image of the body long depended on a symbolic system that seemed to overlook the opposition—obvious to us—between the material and the spiritual. The body was not distinguished from the soul; the work

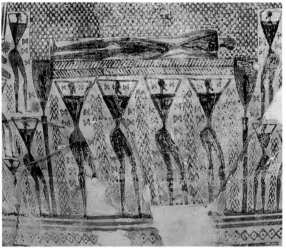

of art was a composite figure that inextricably conflated the appearances of the body and the beliefs relating to the soul. The statues of early antiquity in Egypt, Babylonia, and Mycenae (pre-Classical Greece) were conceived on a gigantic scale, representing the Titans and colossi that populated religions, embodying the powers of spirits. These immense effigies began to fall out of favor at the end of the Archaic age of ancient Greece (c. 500 BC), gradually replaced by the human-scale figure. Artists thenceforth began to draw the distinction between body and spirit, and it became appropriate to assess sculptural forms in terms of their depiction of actual appearances.

Starting in the 5th century BC, Greek thought, which had a profoundly geometric tendency, redefined the body,

The earliest Greek pottery was decorated with abstract linear and geometric motifs. By the 8th century BC schematic representations of human figures began to appear among the designs, painted in black silhouette. The most frequent themes concern funeral rites. Left: a scene of the display of a corpse. The upper body is formed of a simple inverted triangle, the pose is frontal and flat, and the zigzag shape of each figure is echoed in the surrounding rhythmic patterns.

In the next century, sculpture in the round developed in Greece, marking the advent of true figurative representation. Right: the so-called *Lady of Auxerre*, c. 640 BC, shows the continuing stylization of the body, with patterned hair, columnlike dress, frontal stance, and fixed facial expression. But the notion of figurative representation remained somewhat unclear. The linguist Emile Benveniste (1902–69) has pointed out that the Greeks at this time possessed no specific term for *statue*: "The people who set the most complete canons and models of sculpture for the western world must have borrowed from other peoples the very notion of figurative representation."

moving away from the criteria of its religious qualities and toward those of relations of symmetry and proportions: the new standards of beauty. Determined now according to number and measure, the image of the ideal body still did not appear in nature, which remained the domain of the approximate, ruled by neither exact computation nor rigorous geometry. Insofar as beauty exists, it is present only in an imperfect form and by accident, because it is in essence an attribute outside of common experience. The Greeks formed their concept the ideal body starting from the real human body—but a body purified, a model for what in reality can never be more than its imperfect, mortal image.

The *Aphrodite of Cnidus,* the work of Praxiteles (c. 350 BC), is one of the first entirely nude female sculptures. Carefully naturalistic (it was originally painted), it reflects the Greek theory of *mimesis,* which holds that the principle of art lies in the faithful imitation of reality. But because it represents Aphrodite, goddess of love, rather than an ordinary woman, realism of representation requires an idealized form of the female body: an image of absolute beauty.

"Beauty is realized little by little, through many numbers" (Polyclitus)

Born at the beginning of the 5th century BC, Polyclitus was one of the first sculptors to codify this ideal of the human form in a canon of proportions: a set of rules that defines beauty according to a series of measurements. To illustrate this, he sculpted a spear-bearing athlete, the *Doryphorus* (called the *Canon*), which, according to the Roman writer Pliny (1st century AD), "incarnates the principles of art in a work of art."

The Egyptian canon of the human figure was based on the segmentation of the body, each part having its distinct value. Thus, unnaturally broad shoulders or large eyes conveyed specific, intended meanings. The Classical Greek system of proportions considered the figure as a whole, as well as its pose. It regulated the body's development in space, taking into

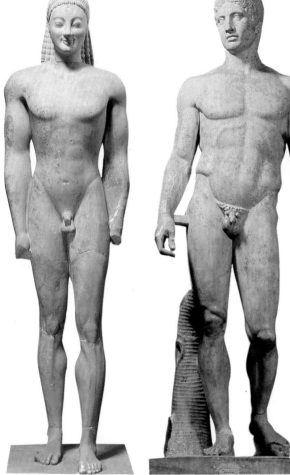

Unlike female figures, standing male statues were entirely nude beginning in the Archaic period. Far left: in the 6th century BC, the male counterpart of the female *kore* is the *kouros,* often a funerary sculpture. Set upon a tomb in a hieratic pose that reveals vestiges of an Egyptian influence, the *kouros* does not bear the features of the deceased. He stands in the place of the departed, commemorating his vigor and beauty through idealized traits such as a formal, frontal pose, patterned hair, broad shoulders, and a long, narrow waist.

Near left: a century later, in the *Doryphorus* of Polyclitus, the masculine ideal has acquired a more naturalistic form, though traces of stylization remain in the symmetrical pattern of the torso muscles. In general, musculature is built up from within, based on geometry. The body's parts relate to one another and to the whole according to a rule of commensurability, so that this spear-bearing soldier may be said to be a theorem in stone. It bore the nickname *kanon* (the canon, or rule). Long considered a perfectly proportioned model, it inspired innumerable copies.

account not only its frontal and lateral projections, but also its contortions and angles, and allowing for illusionistic foreshortening. Greek sculptors abandoned the traditional fixed grid with square fields as the instrument for measuring proportions. This was replaced with a supple system composed of flexible diamond shapes, more capable of rendering active, asymmetrical, natural pos-

tures. The standing statue ceased to be rigidly frontal and formally balanced; instead, it posed in *contrapposto,* twisted in an S shape on the vertical axis, with weight on one leg, hip protruding, and muscles flexed. Grouped figures displayed tension and interplay of forms. An art of transitions, the Greek ideal is based on a science of diagonals.

According to Galen, a Greek physician writing in the 2d century AD, the *Doryphorus* was the practical illustration of a written treatise that has since been lost. Though we do not know the specifics of Polyclitus's rule, other surviving canons borrowed from Greek sources give us an idea of what it must have been. One of these establishes a set of relations for elements of the female form, based on a unit of measure identical to the distance from the neck to the higher breast. The same distance is repeated from this breast to the other, from there to the navel, from the navel to the juncture of the thighs, and so forth. In other words, this system of proportions, like a surveyor's chain, establishes a set of measurements while articulating the pose.

For the Greeks, the ideal body was that of the soldier—the fully realized incarnation of virility and of the most noble social function. The perfect soldier should have a matching adversary, but the modern world takes an ironic view of such idealizations. Here, a

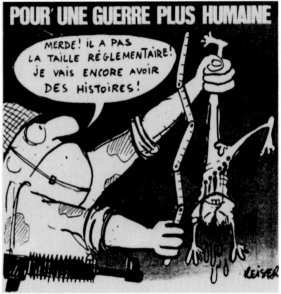

French political cartoonist presents a burly soldier measuring his puny victim and declaring, "Shit! He's not regulation size! I'll get in trouble again!" The wry title of the drawing is FOR A MORE HUMANE WAR.

"Man is the measure of all things" (Protagoras, 5th century BC)

The principle of the ideal canon corresponds to a dual demand for unity. First, this is an attempt to find in the proportions of the human body those of nature as a whole—beauty was considered by the Greeks as the proof of a harmony between humankind and the universe,

microcosm and macrocosm. Second, the body reflects the unified city-state—the principle of a homogeneous and well-ordered state that was the basis of Greek society. Confronted by the diversity of humanity, the ideal figure exalts the feeling of belonging to a community. This figure assumes that culture rests on the dynamic between the one and the many. The unity of the ideal body refers to the unity of the social body. This explains the importance assumed by measurement in an art in large part dedicated, in its principles at least, to the repetition and celebration of established forms. The most able artists had disciples who copied their works. The notion of artistic uniqueness or rarity, of art for art's sake, was alien to the Greek consciousness, which relegated artists more or less to the rank of manual laborers, a group without particular prestige. In Greek the word for *art* is the same as that for *technique;* and in the chorus of the nine Muses, the goddesses who preside over the arts,

The term *proportion* designates a mathematical concept that derives from the Greek Classical tradition. For Euclid it marks the equivalence of two relationships. Classical aesthetics, which identifies the principle of beauty in the relationships of parts to one another and to the whole, is based on this idea of proportion. Expressed not by measurements but in terms of fractions and ratios, the same proportions can be applied to the human body, the plan of a building, or the geometry of an entire city.

Renaissance architects who explored the Greek intellectual heritage conceived of the idea of the city as an organic body—the body politic. Mirroring the ideal city invented by the Greeks, Italian urban planners tried to apply the proportions of the human body to the rational organization of cities. The metaphoric drawing at left, depicting a fortress, appears on the first page of an architectural treatise by Francesco di Giorgio Martini. The central plaza of the walled town is superimposed on the figure's navel, the church is set in the position of the heart, and the governor's palace crowns the head.

none is assigned to painting or sculpture. The relative anonymity to which visual artists were consigned did not, however, abolish every mark of original workmanship.

In Classical Greece, the canon no longer exerted—as it had among the Egyptians—a resolutely normative power. On the contrary, in setting the rules of the game, it stimulated the spirit of competition, and artists individually sought the best ways of expressing it. The ideal body was the product of no single artist; exposed to public judgment, it invited criticism as well as controversy, and to gain the support of citizens was necessarily as universal as a theorem.

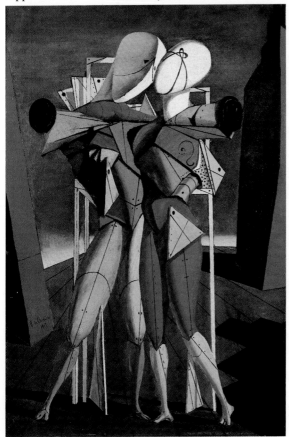

In making the body conform to a mathematical and architectural model, Greek art identified certain geometric forms with human forms. The swell of a curving staircase or the profile of a molding may evoke the slope of an abdomen or the contour of a face.

Left: the Trojan hero Hector and his wife, Andromache, as reimagined by the painter Giorgio De Chirico (1888–1978) in 1917.

"In geometric mathematization…we add to the world of life…a clothing of ideas fashioned from the open infinity of possible experiences, and finely suited to it."
Edmund Husserl,
The Crisis of European Sciences, 1936

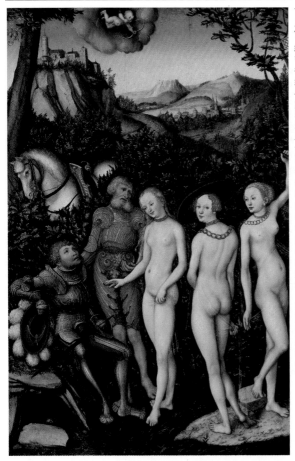

In a Greek myth, Paris, son of the king of Troy, was ordered by the god Zeus to determine the most beautiful from among three Olympian goddesses, Aphrodite, Athena, and Hera. Each pleaded her case, promising the young man a gift if he would choose her. Athena offered him wisdom and victory in battle, Hera sovereignty, and Aphrodite love; Paris chose the last. The legend suggests that when it comes to ideals of beauty, aesthetic judgment is not a matter of wisdom or power, but closely linked with desire. Intrigued by the enigma of beauty, painters since the Renaissance have often depicted *The Judgment of Paris.* Left: the German painter Lucas Cranach's 1530 version presents the three ladies in the pose of the three graces and Paris as a cavalier in armor.

From the 6th to the 4th century BC, Greek art evolved with no sudden mutations. Artists handed down their knowledge in the form of rules of proportion. The ideal body aspired to perfection; measurement was the means by which it endured.

The Renaissance: in the footsteps of Greece

Greece exerted a determining influence on the art of the Renaissance. After a long period of dormancy, the Classical theory of proportions regained its prestige in late-medieval

Europe. In Italy especially, sculptors and painters aspired to capture the Classical spirit by taking the measurements of antique statues. They were not mere copyists of the ancient style, however. The Florentine architect Leon Battista Alberti (1404–72) wrote in *De Statua,* not without irony, that a sculptor should execute half of a statue on the Greek isle of Paros (source of the fine white Parian marble prized by ancient sculptors) and the other half in the Tuscan mountains of Carrara, where the best Renaissance marble quarries lay. In other words, the artist should derive artistic ideas equally from Greece and Italy. As Classicism was transformed by the Renaissance, so too was the concept of "the ideal" revised. Whereas

Artists of Renaissance Italy were able to examine ancient Greek and Roman sculptures in the collections of their wealthy patrons. Many of these beautiful and refined works were damaged—missing limbs or a head—but were not the less exquisite for being incomplete. Michelangelo was fascinated by these ancient sculptural bodies, which

for the Greeks beauty was an abstract notion, with no equivalent in nature, the Renaissance considered that it belonged to the world of the senses. It was up to the artist to discover it interwoven in the universe of forms.

"Inasmuch," Alberti said, "as nature clearly shows the dimensions of the body by deploying them in sight of everyone, the painter will draw considerable advantage from the effort expended on recognizing them in nature itself." The Renaissance artist was no longer a simple artisan concerned with perpetuating a fixed model of beauty, but a thinker who drew on a personal vision. Thus,

retain such beauty despite their mutilations. Above: his rough model of the torso of a reclining figure is based on a Roman sculpture of a river god. It was a sketch for a sculpture on the tomb of Lorenzo de' Medici in Florence.

Alberti proposed certain modifications to the antique rules of the ideal: "Vitruvius," he said, "measures the height of a man in feet [i.e., in meters]. I think, for my part, that it would be more worthy to relate all the other quantities to that of the head." He meant that artists should not follow pedestrian rules rigidly, but should think about what the rules mean. The human body

should be measured by the new ambitions of painting, less a matter of literal measurements than of judgments.

Divine proportion

With a yardstick in one hand and a theorem in the other, Renaissance artists struggled to reconcile the organic and the geometric. They scanned the body and saw numbers. Leonardo da Vinci (1452–1519) inscribed the model human figure in a circle and square, grappling in the process with

L eft: Leonardo da Vinci's 1490 *Vitruvian Man,* an anatomical study based on the proportions for the human figure proposed by Vitruvius. "Note," wrote Leonardo, "that the navel is located at the point of intersection between the extremities of the extended limbs…and that the height of a man is equal to the distance between his two extended arms."

B elow: in about 1510, the German Renaissance artist Albrecht Dürer, seeking to establish simple geometric relations between the parts of the body, made this study of the proportions of a female figure with the help of a ruler and a compass.

the old mathematical conundrum of how to square the circle. Albrecht Dürer (1471–1528) compared the nude of antiquity with measurements he had taken of more than two hundred people for his *Four Books on Human Proportions*. Piero della Francesca (1420–92), mathematician and painter, marked some 130 points on a human face and measured the distances between them in order to create an accurate image of it. At about the same time,

In his book *De Divina proportione,* the Italian mathematician Luca Pacioli attempted to reconcile living bodies and geometric bodies. In this portrait by Jacopo de' Barbari, he stands, dressed in his monk's hood, between a young

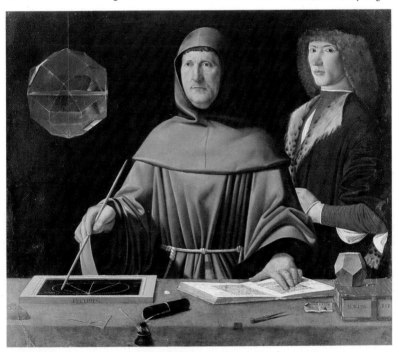

anatomists were performing dissections and autopsies on human cadavers, and learning ever more about the real measurements, inside and out, of actual human beings.

In Venice in 1509, a Franciscan monk, Fra Luca Pacioli, published a book on mathematics that won him great notoriety, *De Divina proportione* (*On Divine Proportion*), for which Leonardo provided illustrations. Pacioli examined past treatises that discussed the theory of ideal proportions, from Euclid (c. 300 BC) to Leonardo Fibonacci

man and a hanging polyhedron with a crystalline structure. On the table before him are the instruments of his profession, including a slate inscribed with the name Euclid.

(c. 1170–after 1240). He believed that a form attained fulfillment if it was the expression of a mathematical principle. He returned the human body—which he called the "small Universe"—to its place at the heart of the macrocosm. Humankind appeared, more than ever, as the measure and the symbol of the universal order.

The decline of canons: the body out of scale

For millennia, humanity had considered itself the measure and standard of all things, but this concept lost its power once the world was no longer perceived as a closed system. As the limits of the universe began to expand before Galileo's telescope, humankind's centrality in the scheme of the universe melted like snow in the sun. The French philosopher and mathematician Blaise Pascal (1623–62) called the human race back to a proper modesty. An entire chapter of his *Pensées* (*Thoughts*), subtitled "Man's Disproportion," was intended to put us in our place: "I would like [man] to consider nature seriously for once and at leisure, to look at himself also, and to know what portion is his…, a nullity with regard to the infinite."

Painters of the 16th and 17th centuries reflected humanity's diminished status. They attacked the glorious image of the ideal body, depicting imperfect and distorted human figures with relish. For some Mannerist and Baroque artists, the human body remained an important

Oskar Schlemmer (1888–1943), director of the theater workshop in the German Bauhaus school in the 1920s, created costumes that reduced the body to simple geometric elements: circle, helix, cone, sphere. His performances integrated the visual forms made by actors with choreographic effects. Left: when an actor wearing this geometric costume rotated, he was transformed into a sort of spinning top.

In 1960, the French painter Yves Klein produced a series of pictures titled *Anthropometries*. Nude female models coated with blue paint pressed their bodies onto large sheets of paper. The body thus painted its own image.

representation of the world—not as a perfectly proportioned ideal, but as an all-too-human lesson in fallibility.

Artists since the Renaissance have frequently confronted this disproportion, standing the human figure against the great void. In the 20th century, drawings by the Swiss sculptor Alberto Giacometti (1901–66) show a minuscule personage placed in the center of an immense sheet of white paper. This little homunculus stands bravely in the face of the universe's vastness.

From art studio to anthropometric laboratory

By the 19th century, artists had mostly abandoned the theory of perfect proportions. Just when it seemed likely to be consigned forever to the library shelf, it attracted new interest in the sciences. The human body

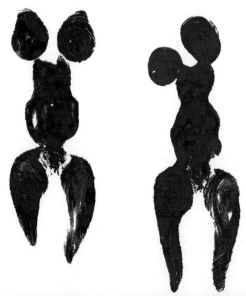

Le Corbusier's Modulor system, developed in the 1940s, was based on his study of Golden Section proportions. He was interested in finding equilibrium among forms, and in designing architecture according to harmonies of shapes and masses. His visual art, like his buildings, was much concerned with rhythms and mathematical progressions. He saw the body as a form in space. Above: a 1955 Modulor drawing.

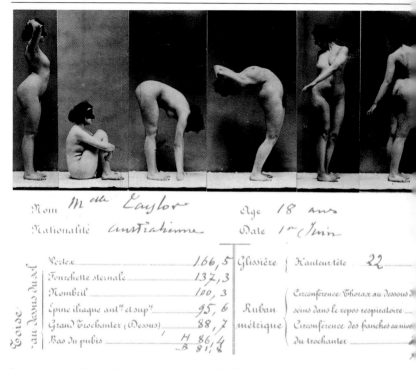

Nom *M^{elle} Taylor* Age 18 ans

Nationalité *australienne* Date 1^{er} Juin

			Glissière	Hauteur tête	22
Vertex	166,5				
Fourchette sternale	137,3			Circonférence Thorax au dessous d...	
Nombril	100,3			seins dans le repos respiratoire	
Épine iliaque ant^{re} et sup^{re}	95,6	Ruban			
Grand Trochanter (Dessous)	88,7	métrique	Circonférence des hanches au nive...		
Bas du pubis	H 86,2 / B 81,8			du trochanter	

Toise au dessus du sol

became the subject of systematic study, and its formation, development, and structures were all called into question. Scientists in the laboratory gathered a wealth of data from the examination of countless bodies. From this detailed scrutiny anatomists concocted one of the strangest versions ever offered of the human figure: an image based on the "average form," in which the ideal was based upon a vague concept of the ordinary. In 1848, a Belgian mathematician, Adolphe Quételet (1796–1874), applied statistical methods to the study of the human body in order to propound his theory of the "average man." This was the first attempt to formulate the idea of Everyman in concrete terms. The body was stripped of all individuality; it was no longer that singular form inhabited privately by every individual, but an impersonal envelope, the shell in which dwelt the incorporeal soul, like a hermit crab in its borrowed shell. Somewhat like the Pythagoreans, who made numbers the

Turn-of-the-century anthropologists used the relatively new technique of photography to document the human body in myriad poses in order to create catalogues of supposedly typical features of the human form. Above: a morphological identification card developed around 1915 by Paul Richer includes photographs and a set of body measurements such as the "circumference of the thorax below the breast during respiratory repose [i.e., exhalation]."

universal principle, the anthropologists of the 19th century tried to reduce the multiple variables of the human being to a few quantitative data. Often, they were interested in discovering physiognomic clues to criminal tendencies. To this end they perfected methods of bodily measurement using a nominally scientific technique known as anthropome-

In 1879, a zealous criminologist in the Paris police, Alphonse Bertillon (1853–1914), proposed to register prisoners on this basis; his brother Jacques (1851–1922), chief of the Paris bureau of vital statistics, introduced a Bertillon classification system for causes of death. Vestiges of these systems of anthropometric classification, or Bertillonnage, are still in use in the commonplace recording on passports and identity cards of the main dimension of the body: one's standing height—the first symbol and last residue of the old vertical ideal that had likened the human being to the shaft of a column.

Measure for measure

At the end of the 19th century this appetite for measurement was not the monopoly of scientists. Functional furniture made its debut: the dentist's or barber's chair lost its rigidity and learned to bend to suit people's differing dimensions. In the world of fashion, the obsession with the waistline became a matter of inches and half-inches: corset manufacturers, hawking undergarments that suffocated women mercilessly, preached—not without a certain gall—the necessity of applying the proportions of Greek statuary to imperfect bodies. This tyranny of

Left: in 1865 Paul Broca (1824–80), one of the first modern anthropologists, invented a method of measuring facial features. The profile of the "average man" from the back of the head to the front of the brow, had, he thought, the dimensions of a double square. Though the notion of determining an average for all humanity may seem simplistic, designers and engineers still rely on statistically based averages when creating furniture and machinery. Below: a 1959 "average human," encased in an armature of numbers.

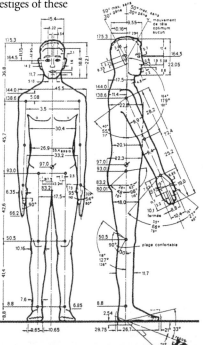

measurement did not spare art criticism either. The most respectable Victorian scholars succumbed to it. Style was judged with a dressmaker's tape measure: a critic named Salomon Reinach dated the Venus de Milo (see page 132) to the Classical period by virtue of her bust size, while Paul Richer, considering the width of the hips, judged her as belonging to the Hellenistic (which is, in fact, accurate).

A catalogue of human types

At the turn of the 20th century the techniques of anthropometry were applied to dubious attempts to determine racial and morphological types, in a process known as typology. The aim was to identify races according to scientifically established characteristics, grouping together the traits common to a given set of individuals to describe a race or class. The analysis of human types offered the scientist the advantage of being able to theorize on the basis of a few simple models, but its motives were frequently racist, and its main drawback was an appeal to criteria that were

The study of body types in the early 20th century led to a conceptualization of the human form as a set of faceted blocks. This interest in the geometric body was more or less contemporary with Cubism in art. Below: a schematic drawing of the "four basic morphological types" from a 1924 book by A. Thooris; opposite above: a "muscular cubic type" from the same volume; opposite below: an "ideal man," from a 1931 German book. Volumes of such photographs were published presenting the "pure Aryan" as the ideal physical type.

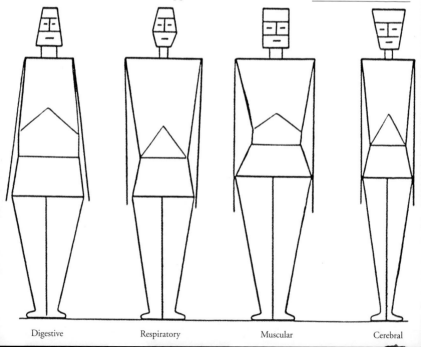

Digestive Respiratory Muscular Cerebral

at best contestable. What body corresponds to the norm? Which ones should be excluded for violating a standard? The categories were highly subjective, and could not be freed of the prejudices of their authors, so that they differed from study to study. They sometimes gave rise to questionable sciences such as eugenics, dreamed up around 1880 by the British physiologist Francis Galton (1822–1911), a cousin of Charles Darwin, who aimed to select and improve the human race according to a type judged (by him) to be ideal. He is perhaps best known today for his pioneering system of fingerprint identification.

The notion of human types is not new. Sanskrit and ancient Indian erotic literature, such as the *Kama Sutra,* classified women according to body types: the *Padmini,* or Lotus woman, with fine skin, full bosom, straight nose, swan-like gait, and three folds or wrinkles across her waist, the most perfect of feminine types; the *Chitrini,* or Art woman; the *Shankhini,* or Conch woman; the *Hastini* or Elephant woman. Similarly, nearly all works of art valorize precise physical types which, easily identified, become almost the signature of an artist or an era. The masculine type in Michelangelo's 16th-century work, with its

In theory, the concept of racial types is a simple zoological classification system, independent of cultural or political notions and implying no preeminence of one race over another. The reality is more complex, since the concept of "race" is itself subject to varying cultural influences. The 20th century's interest in such classifications has had tragic consequences. In the 1930s, the Nazi movement in Germany developed a violently racist political ideology based on the supposed physical and mental superiority of a vaguely defined German race, given the name Aryan.

muscular armature, differs from the bony, elongated nudes valued by the Austrian painter Egon Schiele (1890–1918; see page 152). The Gothic female type, with long waist, swelling belly, and small, high breasts, contrasts with the fleshy, plump ideal of Pierre-Auguste Renoir's Impressionist nudes of the 1880s.

Metamorphoses of the ideal body

From the Egyptian canon to the Modulor architectural system (based on the proportions of the human body) invented in 1947 by the Swiss architect Le Corbusier (1887–1965), the diversity of rules of proportion suggests the failure of any single notion of the ideal body. Underlying this eternal interest in ideals is a deeply embedded faith in the virtue and certainty of measurement. Human beings are enchanted by numbers and their harmonies; we bind the body in a web of invisible geometry in our desire to give it its full measure, to restore its abstract value. Whether the canon be mystical, aesthetic, or flatly realistic, the reduction of the body to a few schematic dimensions cannot long satisfy either the artist's taste or the scientist's curiosity. On the other hand, to abstract from the human body the rules that govern its organization, to substitute a simple, invisible schema for the complexities of visible bodies, is to recognize the intricate relationship between the idea of the

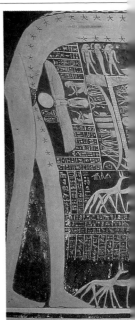

Yet another incarnation of the ideal body is that exemplified in beauty pageants. Such contests perpetuate the idea that there exists an exemplary female body, a model of absolute beauty. This perfect form, ephemeral though it may be, reduces every other woman to being—to quote Charles Baudelaire —only "a piece of the *essential* woman." From generation to generation, however, tastes change and the ideal body of the 1930s (left) may look oddly plump by the standards of the 1990s.

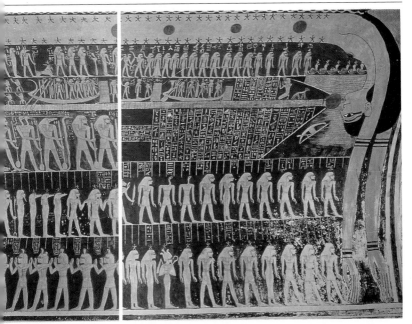

body and the countless individual bodies that populate the world. The act of measuring implies an initiation into a mystery. It is not only a matter of calibrating, gauging, calculating the length, bulk, weight, or color of the body, but also of evaluating, appreciating, and making a judgment, in order to arrive at the understanding of forms. Nicholas of Cusa wrote in 1450 in *De Idiota* (*On Language*): "I conjecture that the word *mensura* [measure] has the same origin as *mens* [mind]."

An ideal is a product of the human spirit. It is the revelation by which the reality of the body is revealed to us. The canon of proportions, then, is rooted in the deepest intentions of the artist and his or her culture. Thus, metamorphoses of the ideal follow the shifts of civilizations. The French philosopher Charles de Montesquieu (1689–1755) remarked ironically: "We never judge things except in secret reference to ourselves. I am not surprised…that all idolaters have represented their gods with a human face… It has been said, rightly, that if triangles made a god, they would give it three sides."

Above: one of the principal cosmic divinities in Egyptian mythology is Nut, Heaven, depicted here as an immense overarching human body covered with stars. According to legend, Nut swallows the sun at night (visible in the form of a red disk traveling through her body) and returns it to life in the morning through her sexual organ.

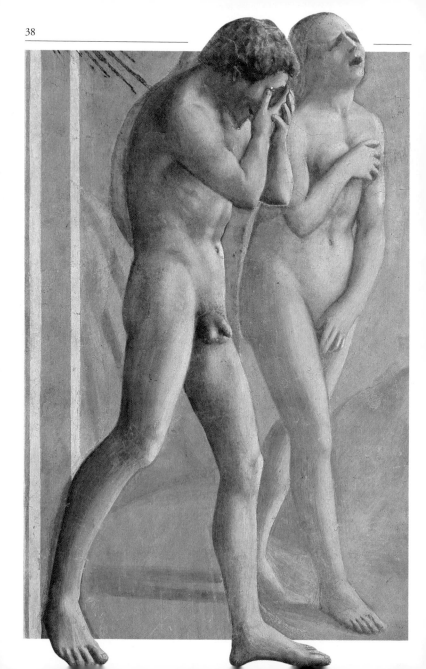

"In those days humans had four arms, and as many legs, two faces, and their shameful parts were doubled, like all the rest...Zeus, to put an end to their undisciplined state, cut them in two as we would slice fruit to make preserves, or the way we divide a hard-boiled egg with a horsehair."

Plato,
The Symposium, speech of Aristophanes,
4th century BC

CHAPTER 2
THE OUTRAGED BODY

Fascinated by the myths of ancient Greece, Renaissance artists identified Adam with Apollo, Eve with Venus. As incarnations of original beauty, the first man and first woman also symbolized the loss of this ideal body. Through them, beauty is overcast by tragedy. Left: Adam and Eve expelled from Paradise, by Masaccio. "The beautiful is nothing other than the beginning of the terrible," the poet Rainer Maria Rilke wrote in *The Duino Elegies.* Right: a distorted depiction of the body conveys much about how we see ourselves.

In his dialogue *The Symposium,* the Greek philosopher Plato (c. 428–348 BC) invents an anthropological fantasy to explain the evolution of the human body, putting his parable in the mouth of the comic playwright Aristophanes. Early humans, he says, were bisexual and double in all their parts. As a punishment for overweening pride, Zeus, lord of the gods, cut them in two and scattered them. Since then, each human has wandered the earth, yearning for its other half and striving unceasingly to regain its shattered unity—the symbol, forever inaccessible, of a lost ideal. The human quest for love, Plato suggests, is a desire to reconstitute the body's primordial unity.

This ancient tale is recalled in the legend of the brothers Telecles and Theodoros told by the 1st-century BC historian Diodorus of Sicily. These two sculptors were commissioned to do a statue of Apollo and executed the work in two distinct parts. The first brother sculpted his appointed half on the Aegean island of Samos, the second in nearby Ephesus, on the coast of Turkey. When they were united, Diodorus tells us, the two halves fit together so perfectly that no adjustment was required. This approach to sculpture is based on a sort of collage principle, and relies on the fine dressing of stone, as in masonry building; above all, it implies an established system of proportions that subordinates each detail to a fixed overall plan.

In *The Eternally Obvious,* by René Magritte, the feminine ideal is recomposed as a series of fragmented images of the body.

The body, however, is no orderly set of geometric forms, but a collection of disjointed and heterogeneous elements that struggles to achieve a graceful integration. If the legend of Telecles and Theodoros ends with a happy suturing, there is a contrary approach to the body that seeks to exploit the scars of its assembly and to emphasize them. Disavowing the norm and the ideal, flouting the canon, this approach displays the body's awkwardnesses, its disproportions and anomalies. Opening the way to caricature, to the grotesque and the monstrous, it exposes the specificity of each body, exalts in particularities, and delights in the enigma of differences, beginning with the foremost division of all: gender.

At the heart of difference: excess

An element of the body that seems to be either an afterthought or the result of a clumsy design is the sex. In Classical Greek statuary as well as in such classicizing Renaissance works as the paintings of Michelangelo, male genitals are nearly always undersized, and often seem to be a flaw in the canonical system of proportions—an error of measurement. As for female genitalia, they

Left: in 1926 Alberto Giacometti created *The Couple,* based on a style he had seen in some African sculptures of paired men and women, particularly among the Dogon of Mali. Refining differences between male and female to a few stylized extremes, he made the woman a curvilinear blade or spoon-shape, and the man a rectilinear wedge or pillar. A few features suffice to mark identity: fingers, mouths or eyes, and sex organs.

The representation of coupling male and female figures is a recurrent theme in art. Below: a drawing of a Dogon bas-relief.

are rarely depicted at all. Is this a sign of prudishness or a desire—possibly subconscious—to gloss over the differences? Men's and women's bodies are not distinguished by their sexual organs alone. A whole set of physical attributes and secondary sexual characteristics mark their difference. Classical art is as sensitive to these—to all the nuances of contour, weight, and scale that contrast female and male forms—as it is resistant to the ostentatious display of the genitals that one may find in some modern and nonwestern art traditions. The understatement of the sexual organs in Classical art seems balanced by the proportionally greater attention given to the rest of the body. Gender is expressed in

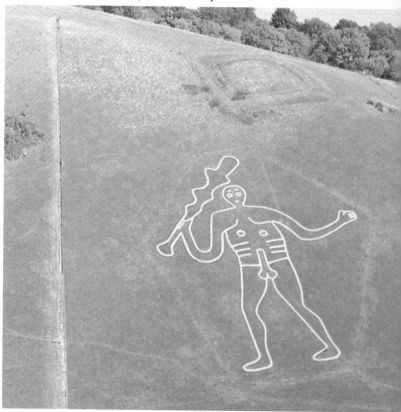

myriad ways in Greek and Roman sculpture: in the smoother or more bulky curve of a leg, in the padding of a shoulder, and in the turn of a neck, and in the rendering of facial features; these subtleties extend the task of observation to the entire body. The artist provokes a kind of generalized Eros. Eros lies at the very heart of the meaning of Classical art, which is less concerned with representing particular gods of fertility or power than with personifying desire in the form of a Venus or Apollo.

However, in art traditions associated with cults of fertility or regeneration—ancient Greek worship of Priapus, for example—the differentiation between male

Certain images incarnate both the hope of fertility and the fear of annihilation. Opposite above: this crouching woman, her face evoking a death's head, her hands holding open her sex, is the Celtic figure Sheela-na-Gig, found on some medieval Irish churches. Her male counterpart may be the giant of Cerne Abbas, England (below left), who, with erect bludgeon and member, can kill or give life. Carved perhaps as much as 2,000 years ago, he measures nearly 180 feet (55 meters) in length.

Below: a Greek priapic cult sculpture, 2d century AD.

"I was once the trunk of a fig tree, worthless wood, when the artist...decided I should be a god."

Horace, *Satires,* 1st century BC

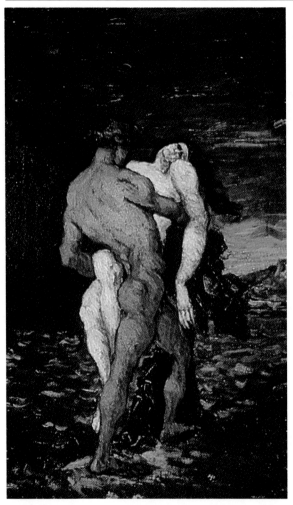

In an early painting, imbued with strong sensuality and attuned to the Classical tradition, Paul Cézanne depicts a classic, distressing theme of painting, *The Rape.* Against a backdrop of dark, menacing landscape that evokes less a country pastoral than the grim depths of the sea, an athlete with bronzed, ruddy skin carries off in his arms an equally muscular woman with a pale complexion. The morphology of the two bodies is only slightly differentiated, and though both are nude, gender is not clearly identified by the usual signs—sex organs, length of hair, or body mass. The only real key to sexual identity is the opposition between the brown pigment of the man's skin and the woman's ivory flesh. This is enough, however, to underscore the difference between the two and heighten the violence of the scene.

and female is made by clear genital evidence. Sculptures and paintings present the male member erect, on a scale that exceeds all verisimilitude. The female sexual organs, equally oversized, are displayed in many statues representing the life-giving mother. In extreme examples, man and woman are represented as simplified, schematic

body units with no physical distinction other than the reproductive organs. Thus, the exhibition of the sexual organs tends to suppress other forms of morphological differentiation. The Dada artist Marcel Duchamp (1887–1968) satirizes this vision of the body reduced to sex in one of his most provocative works, the readymade sculpture titled *Fountain* (1917; see page 152). A porcelain urinal turned 90 degrees metamorphoses into a different sort of receptacle—what might be interpreted as a giant vulva offered to men's needs. He thus parodies the image of woman debased to the level of mere object. "The only female we have is the *pissoir*," he once remarked sarcastically, "and we live off it."

White for women, black for men

If the body can inspire such biting irony (sarcasm means "biting the flesh"), a more delicate approach, more superficial and sometimes much more subversive, contrasts man and woman by the mere play of colors. The pigmentation of the epidermis is one of the most ancient signs used to characterize the sexes. Ancient literature abounds in examples. In Egypt in about 1450 BC, under the reign of the pharaoh Thutmose III, the figures in frescoes are subjected to a color code: men have skin painted in red ocher, women in yellow ocher. This difference in coloration reaches an apogee in Greece on certain decorated ceramic vases of the Archaic period, in which women are painted with a complexion of alabaster white and a hairless body, while men have soot-colored skin. Feminine is opposed to masculine as white is to black. In later Greek periods, the historians Xenophon (c. 431–c. 352 BC) and Plutarch (c. AD 46–after 119) compared the bronzed skin of

An ancient Greek vase depicts male satyrs and female maenads in sharp contrast: black skin for the males, white for the females. Satyrs (half

man, half goat) and maenads (women who take part in orgiastic Dionysiac rituals) symbolize the male and female principles in their primal, half-human form.

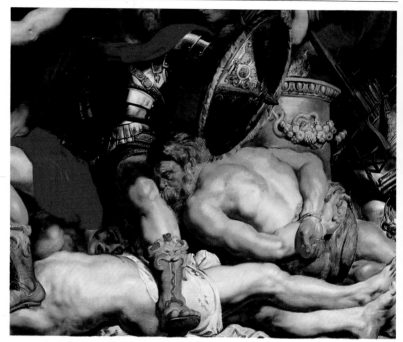

men raised in the open air, exercising in the fields or stadiums, with the pale skin of women, who lived largely indoors and were heavily robed.

The glory of muscles and the triumph of fat

The play of contrasts between the sexes is not limited to the skin. It is expressed in relief in the flesh. While the Classical ideal body implies balanced forms, simple volumes, and a smooth, vertical posture describing a single graceful S curve, the Baroque body of the 17th century is exuberant and extravagant. In northern European paintings of this era the principle of bodily hyperbole is carried to extremes. The characteristic Baroque torso curves in several directions at once, dynamically activated by masses of fat, protuberant muscles, and grandiose gestures.

A century earlier, Leonardo had criticized studies of nudes to which an excessive muscular development gave

In Classical art figures tend to take a few rather static poses: standing upright, reclining at full length, in a state of rest or slow movement. Baroque art treats the body in a state of excited and dramatic action. Bodies are bent, twisted, doubled up, compressed. Above left: *The Victor's Triumph* by Peter Paul Rubens; above right, *The Daughters of Kecrops* by Jacob Jordaens. Far right: a label for French Camembert cheese reads, cheerfully: 45% FAT.

45% DE MATIÈRE GRASSE

the appearance of "sacks of nuts." These knotty Herculeses and stocky Adams had little to do with the adepts of bodybuilding. Their morphology owed less to observation of live models than to an overstated adherence to the traditional rules of statuary. Under the exaggerated bulges and furrows of Peter Paul Rubens (1577–1640) and Anthony Van Dyck (1599–1641) one can detect, faithfully reproduced, the dominant traits of Classical Greek art, but as if enlarged and seen under a magnifying glass. In these apotheoses of virile strength, the corporeal machine is dramatized to the point of robust caricature. Contrary to this display of force in the male physique, the Baroque image of woman is frequently mired

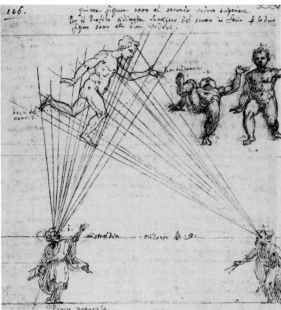

Painters often adhered less rigorously than sculptors to the canons of proportions. To conceive of the body sculpturally, as a measurable reality in space, requires an essentially volumetric approach to it. In contrast, the painter's use of perspectival foreshortening favors the play of appearances over the reality of accurate measurements. As the 19th-century painter Eugène Delacroix noted, "It's not the thing that you have to make, but only the appearance of the thing." Left: a 1550 perspective study, after Leonardo, shows the various kinds of distortions of the body required by different points of view.

Artists often cultivate disproportion, exaggerating or reducing certain parts of the body for expressive purposes. Opposite: in this Mannerist *Birth of Cupid,* an elegantly reclining Venus—a classic theme in 16th-century painting—has feet too small and attenuated to be of much use, should she ever wish to stand up.

in adiposity. The female body swells like a dimpled sausage. The Venus of antiquity, firm and lithe of body, subject to the rule of number, gives way to a body that to modern eyes seems unnervingly overfed.

The Classical spirit, committed to the exploration of structure, exposes the armature of the body beneath the skin's relief. The Baroque spirit is in some sense anti-Classical, hiding structure within under a mound of flesh and concentrating its attention on surfaces and appearances. In place of ideal forms is a fascination with rich textures and colors; in opposition to a uniform model is the pleasure of variety.

The body in *flagrante delicto* of disproportion

Nonetheless, within each of the fleshy Graces of Rubens lies a skeleton that adheres to the canon of proportions of Praxiteles. Surface rotundities obscure but do not alter the ideal that exists within. A pictorial opposition between muscular male and pliant, padded female types, however caricatural, remains dependent on the rules that

it seeks to undermine. Fat and muscle alone did not dismantle the Classical canon of proportions. What did that was the point of view of the spectator.

Painterly perspective, a key invention of the Renaissance, relied on the concept of foreshortening. Once mastered, this trick became the keystone of all Baroque metamorphoses. When the viewer of a painted scene observes it from above, or from a low angle, measurements are distorted to suit and the body folds up like an accordion. An eyebrow brushes against the navel. A shoulder hides behind the toes. Forms that are telescoped so blithely offer the beholder an unexpected play of discoveries and equivocations. The straight line—prime symbol of Classical art—becomes a spiral; tension becomes contortion; energy is released explosively.

Impossible postures and aberrant points of view delighted painters

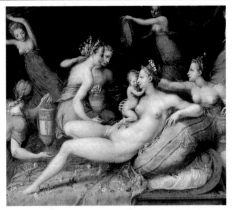

This study of a fore-shortened figure by Tintoretto views the figure from below, accentuating the body's tension.

eager to avoid the tradition of faultless, bloodless works whose exactitude stripped them of all interest. Bodies were twisted and rules were bent. "Some artists," the classically minded Alberti commented with disdain, "go so far as to offer the viewer the chest and the buttocks at the same time, which is impossible to do and very indecent to show." In restoring to the body its enthusiasm and turbulence, the Baroque spirit not only broke with Classical serenity, but placed greatest value on those elements of art that escape calculation and rationality. Where Classicism presented the body as a long-considered idea, the Baroque offered the body caught by surprise and emphasized the brutal, often ephemeral nature of its revelation.

Object of ridicule or pity, the body joins the ranks of the real

Even the most daring foreshortenings of perspective never denied Venus and Apollo the privilege of youth. The alert body refers to an adulthood that has barely emerged from adolescence. It incarnates a fragile moment of perfection. In the wake of the revolution that rejected Classicism, art began to make room for all the bodies ignored by the ideal, to display bodies in disgrace, and to barter beauty for truth.

Portraits of wrinkled crones, of emaciated or bloated invalids, of pregnant women and chubby infants express an entirely prosaic reality that contrasts with Classical refinement. This is an attempt to embrace nature closely, to show—and sometimes to dramatize—deformities, physical suffering, the ravages of age: in sum, to depict pathos. Grimacing figures, dwarves, and hunchbacks are the counterweight to gods and goddesses.

Refusing to subsume all humanity into a single, perfect, emblematic figure, realism explores the

A bove: an illustration from Dürer's treatise. "No little art is needed to make many various kinds of figures of men…No single man can be taken as a model for a perfect figure, for no man lives on earth who is endowed with complete beauty…How beauty is to be judged is a matter of deliberation."

Albrecht Dürer,
*Four Books on Human
Proportions,* 1528

multitude of individuals. The successive stages through which each of us passes between birth and death offer an inexhaustible repertoire of bodies and configurations. Realism attempts to capture the numberless minute alterations to which time subjects the body. It is an impossible task, and artists sought for methods of managing this overwhelming diversity of bodies: they desired a means of measuring excess.

In his *Four Books on Human Proportions*, published in 1528, Dürer outlined five canons of proportions for man and woman, gross and rustic, tall and thin, moderate, and so on, but conceded

Duane Hanson's hyperrealist sculpture *Housewife* (1970), cast in synthetic resin, painted in oils, and dressed in real clothes, transforms the everyday into a spectacle. The effect depends on the absolute accuracy of the reproduction.

that he was a poor judge of which was the best—especially since all intermediate stages are also possible. "One form can transform itself into another," he wrote. "The logic of this variation is infinite—and thus it is impossible to say how much license is allowed a work of art." He proposed a geometric method for modifying "to everyone's satisfaction" the proportions of the body he had established. He called this "a perfect instrument for corrupting images…under the name of corrupter." Unable to define beauty with certitude, Dürer systematized ugliness.

Below: a 1668 series of studies by Charles Le Brun on the facial expression of the passions; right: an 1862 photograph from Guillaume Duchenne de Boulogne's study of facial expressions. Duchenne composed "an orthography of the face in motion," using the new science of physiology and the new technique of photography.

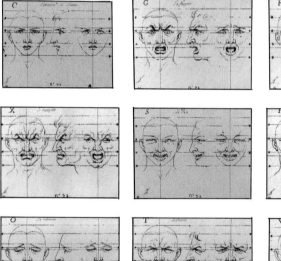

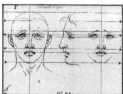

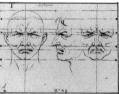

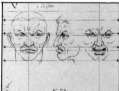

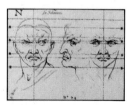

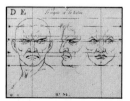

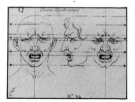

From variety of bodies to diversity of expressions

In addition to permanent alterations, one may also study temporary disturbances of the body. In realism, the Olympian calm of Apollo, who embodies an ideal of expressive restraint, gives way to grimaces and excited hand motions. The body, free to express emotion, becomes furious, jealous, sad, contemptuous, joyous. In this pantomime the face plays the prime role. In 1668, Charles Le Brun (1619–90), official painter to King Louis XIV of France, presented to the Académie his *Lecture on General and Particular Expression,* which followed a rather mechanical theory of the passions expounded by the philosopher and scientist René Descartes (1596–1650). To illustrate his ideas, Le Brun sketched a series of twenty-three heads that constituted an array of states of mind acting on the facial muscles, from rage to hope, from fear to laughter to hate. These effigies of desire and sorrow all derived from a common ancestor: tranquillity, the absolute zero of the emotions—a face that is master of itself and that dons and removes the masks of the passions in the manner of an actor.

Reduced to interpreting emotions, the body loses its reassuring opacity

The idea of associating physical particularities with character traits is very old. "Let me have men about me that are fat," says Shakespeare's Julius Caesar in 1600. "Yond Cassius has a lean and hungry look; he thinks too much: such men are dangerous." This notion enjoyed a considerable revival in 1775, when a Swiss theologian and mystic, Johann Kaspar Lavater (1741–1801), published a ten-volume

"The free expression by outward signs of an emotion intensifies it… He who gives way to violent gestures will increase his rage; he who does not control the signs of fear will experience fear in a greater degree.**"**
Charles Darwin,
The Expression of the Emotions in Man and Animals, 1872

Franz Xaver Messer-schmidt (1736–83), an Austrian portrait sculptor, became interested in grimaces and other facial expressions, and their connection to pain. He made some 50 or more "character heads," such as *The Yawner,* below.

study of what he called "physiognomy," on which the German author Johann Wolfgang von Goethe (1749–1832) collaborated. This was a veritable catalogue of human features. Assessing the penchants and inclinations natural to each person, Lavater saw in physical traits the simple reflection of psychic traits. If souls may be likened to expressions, his study suggested, then temperaments are comparable to physiques.

Extending his theory, an Italian criminologist named Cesare Lombroso (1836–1909), asked in 1875 whether certain anatomical traits—scientifically measured—could be said to characterize a "criminal personality." He developed a notion, radical at the time but wholly discredited today, of the delinquent as an anthropological type, a personality determined by heredity and identifiable by physical features such as facial asymmetry, an unusually large or receding jaw, or prominent ears. Thieves were held to have flattened noses; murderers' noses were likely to be aquiline.

This rather harebrained idea was given a certain credence, perhaps because a feature or gesture often goes much farther than words in expressing attitudes and conveying impressions. The body thus becomes, unwillingly, the theater of the moral and intellectual condition of the person. But such pseudoscientific theories are ripe for pernicious distortion. If judged by physical appearance alone, human beings would need to offer no further proof of their talents or failings than the face of a genius or an assassin's mug.

The caricaturist's distorting lens

Caricature mocks the face of the brute, the smart alec, and the flirt, giving full play to the grammar of forms identified by students of the face from

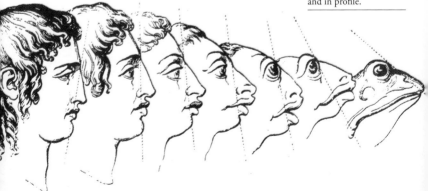

Leonardo to Lombroso. Just as 19th-century anthropologists attempted to fix categories of human types, and in doing so exaggerated some concepts, so caricature documents physical particularities, and by stressing a grimace or underscoring a prominent feature seeks to establish types of expression. Caricature assumes the existence of an individual, however banal in proportions, neutral in emotions, and undifferentiated in temperament. It is not, as has sometimes been claimed, a reaction against the rule, a form of rebellious portrait. Rather, its derisiveness implies the keen consciousness of a standard body as the norm from which each individual's deviations are sketched. The great vogue enjoyed by the caricature in the mid-19th century is not only contemporaneous with the notion of "average man" in anthropology; it is allied with it.

Caricature, in focusing on those elements in the body that may most readily be exaggerated, inevitably stresses

Johann Kaspar Lavater proposed an early theory of evolution, which held that humans were descended from amphibians. The caricaturist Grandville (Jean-Ignace-Isidore Gérard, 1803–47), mocking him, imagined an evolution in reverse. He produced two series of drawings called, respectively, *Man Descends toward the Brute* (1843) and *Apollo Descends toward the Frog* (1842).

Opposite: the caricaturist Gavarni portrays the eminent 19th-century author Honoré de Balzac nude and in profile.

its strangeness by giving it an appearance that is less and less human. It is a distorting mirror that transports the image of the body to the border of the fantastic.

Half man, half beast, the monstrous body joins the parade

Plato comments in the *Timaeus* that animals are humans reduced to a degraded form as punishment for excess. They reflect the humiliating condition that awaits humankind from the time when, refusing to master themselves, men and women let the passions of the body tyrannize over reason. Grotesque art rejects Plato's moral condemnation of the bestial and celebrates the metamorphoses of the body, the unbridled sexual energy that generates monsters.

Greek myths are full of creatures that combine the human and the animal— fauns, centaurs, satyrs. Gods assume the guise of beasts at will. In the pantheon of ancient Greece, the drunken god Dionysus, patron of the theater and of phantasmagoria, is master of these, and incarnates the suppressed world of the forbidden body. His cult celebrates the otherness of human beings. Dionysus is sometimes represented in the form of a simple mask, a pure facade. His universe represents the irrational, imaginative elements of human nature, the living vestiges of our animal selves.

The body in limbo: a monstrous genesis

The pictures drawn by young children often capture this curious, atavistic

The monstrous oscillates between the grotesque and the terrifying, the alluring and the repugnant. This category gives concrete shape to our fantasies and phobias. Left: Baubo, a strange creature from Greek mythology, is a woman with her face in her pregnant belly. She is a joker or trickster figure, like the male Priapus.

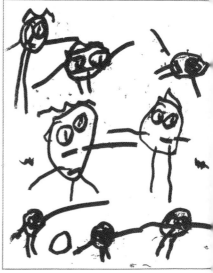

This image, inspired by a drawing by the Austrian physicist and philosopher Ernst Mach (1838–1916), shows what is perceived by the left eye of an artist sketching his own body. It's a self-portrait without a mirror. Delimited at top by the arch of the eyebrow, at right by the nose, and at bottom by the cheekbone, the body is circum-scribed within an oval form from within which the torso and legs protrude, inverted like the finger of a glove turned inside-out.

Opposite: drawings of human beings by a three-year-old child. In early childhood the child perceives the world as an undifferentiated exten-sion of his or her own body. Awareness of the self is born at the frontier that the child traces between his or her body and the outside world. At about three years, a child's first self-portrait is a closed circle, containing large eyes and mouth, that divides an inside from an outside. Limbs are wispy and vestigial, and the trunk nonexistent.

mixture of the human and the inhuman. Around the age of two or three, a child will draw an image of him- or herself as a large head with limbs sticking from it like filaments. Awkward and grotesque, this hybrid creature rather resembles a protozoa. This suggestive visual correlation between the most rudimentary organisms of the animal world and the human child's first figurations of the human body illustrates a theory conceived in 1868 by the German geneticist Ernst Haeckel (1834–1919), according to which the development of each individual reproduces in brief form the evolution of the entire species: ontogeny recapitulates phylogeny. Is it so fan-tastic to propose that those palaeolithic female figures, round as grapes, oddly resemble the clusters of cells that are the most elementary stage of life—its prehistory?

The monster, like the ideal figure, is an enduring image. One is the eternal human, the other the creature that haunts it eternally. A monster, as the etymology of

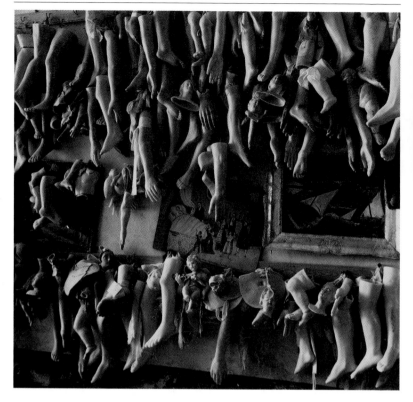

the word implies, is that which displays or reveals itself. At once essential and alien to a culture, the monster represents danger, that which must be excluded. Throughout history, artists have been as intrigued by the representation of the repulsive as by the beautiful; the one defines, in a negative image, the limits of the other. The monster is the opposite of the ideal body, and its counterpart.

The ultimate monster is the body in a state of corruption. Like genesis, degeneration is the result of a disturbance of equilibrium, the triumph of excess. When the body is thrown sufficiently off balance it collapses. Asymmetry is the artisan of the monstrous just as stability is the material of the beautiful.

These body parts, clustered together like fruits on some vine in Hell, are wax ex-votos, representing suffering organs and sick limbs, in the sanctuary of San Alfio at Trescastagni, Sicily. In some Catholic traditions ex-votos are offered to the Virgin Mary or to a saint in prayer for a cure or in thanks for a cure granted.

The dismantled body

Destroying the body is the final stage in the long series of metamorphoses that began with the ideal figure, symbol of harmony and unity. The image of the mutilated body, methodically dismembered, is a culmination. The great 19th-century French sculptor Auguste Rodin kept his unfinished sculptures, his rough sketches modeled in haste, heaped up in a corner of his studio. He referred to this amalgam of scattered heads, legs, arms, and torsos as his "brushwood." His splendid and terrifying work *The Gates of Hell* (see page 153) seems to merge all of these nightmarish fragments, as if the dissolution of the body into parts were the very stuff of damnation.

"If something is still able to wring tears from us…it is no longer beauty…but only a hallucinatory, sordid perversity.…Thus, there is no question at all, despite any contrary obsession, of avoiding this hateful ugliness."

Georges Bataille, *Figure humaine (Human Face)*, 1929

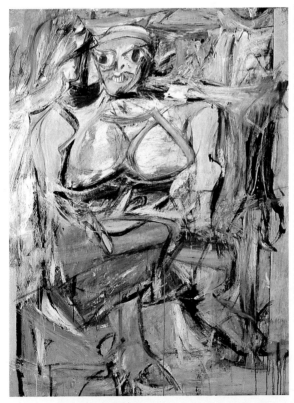

Though artists have always had a variety of reasons to represent the body in distorted or grotesque form, the 20th century has been particularly eager to subject images of the body to contortion and experimentation. The lack of a common scale for apprehending the human form seems to give free play to all kinds of deformity. Left: *Woman I,* by the American painter Willem de Kooning (1904–97), presents the female figure as a terrifying giantess, with teeth bared in a fierce grimace. In a lecture in 1950 (the year he began the painting), de Kooning recounted the fable of the village idiot who spent his time measuring himself and was amazed that his height—for lack of a standard of measure—kept changing.

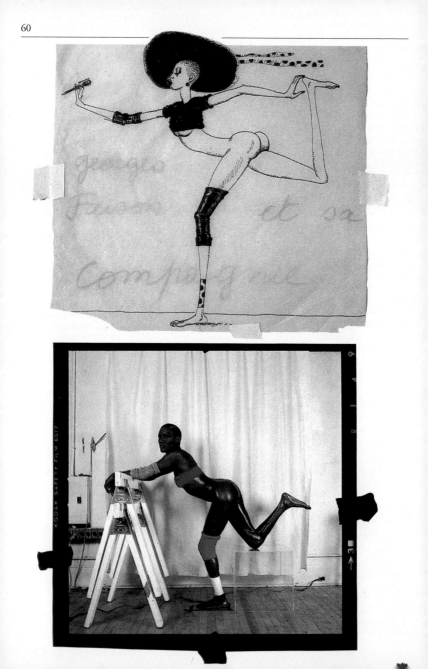

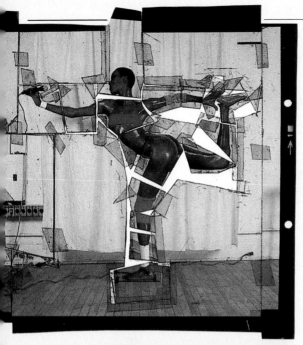

In 1972, Jean-Paul Goude, art director of the American magazine *Esquire,* published a series of illustrations titled *The French Correction.* He first set out to correct his own physical appearance with the help of photographic and other tricks. He then applied his method to other persons. Here, he restructures the body of the Jamaican-born actress and singer Grace Jones. Above, far left: a first sketch; below: the star is photographed. Above, near left: the photo is cut into pieces, the severed limbs are readjusted, and some are reshaped in touch-up. In the final stage (below, near left) the seams are covered with touch-up paint and new highlights are added. Jones's body is thus virtually dismembered and transfigured into that of a dream creature.

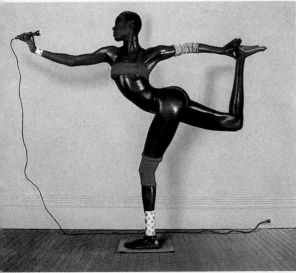

The ancient Greeks, always so attentive to the significance of the body, developed funerary rites that reflected its importance. Whereas *kouroi,* permanent and idealized stone effigies, were erected on the tombs of heroes, the cadaver of an enemy was subjected to a morbid ritual of annihilation called *aikia,* outrage to the body. It was dismembered and its parts scattered, so that it forever lost its formal integrity. The body of a defeated adversary was thus symbolically denied the right to incarnate the values of unity and beauty. The ultimate degradation, for the Classical mind, was the eradication of all traces of the body's existence.

Between ideal and distortion

The image of the body traces two opposing currents. The one seeks the profound identity common to all beings; the other stresses their difference. The ideal tends toward a single, perfected representative figure; the real toward a devolution and ultimate fragmentation. In the 20th century, with the invention of pure abstraction, art made a concerted effort to evict the human body entirely. Yet the body is a remarkably persistent symbol. One tendency in abstract art leads to the geometric ideal exemplified in the work of Piet Mondrian, whose rigid verticals recall the pure, solitary, vertical figure, the intellectual imperative so eloquently articulated in the ideal body of Classical Greece. Another direction is that which expresses the actual condition of humankind, whose unstable flesh is prey to constant disorder. Humanity, as may be seen in the turbulent images of Jackson Pollock, is a creature of chance and change.

Above: this drawing of a distorted man, by the eminent Canadian neurologist Wilder Penfield (1891–1976), shows the body in proportion to the brain tissues that control its motor functions.

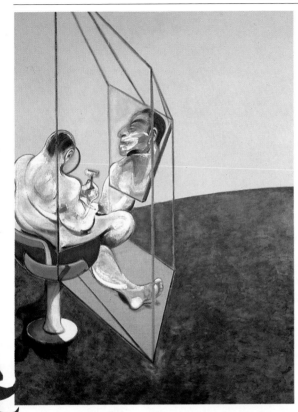

Left: in Francis Bacon's distorted portrait of a man, the disorderly power of the body is contrasted with the crystalline linear framework of a polyhedron. Despite its tormented appearance, the human form is fixed on the canvas in an immutable figure. According to Bacon, "the image coagulates feeling in order to make it last."

The body of a bathing-beauty pin-up is intended to be reproduced, retailed, and exposed to the greatest possible number of eyes. Displaying an exaggeratedly perfect body, a World War II-era pin-up girl, painted on the flank of a bomber plane, straddles a bomb, implement of mass destruction. Such paintings were dubbed "fiancees of death."

HEAVENLY BODY

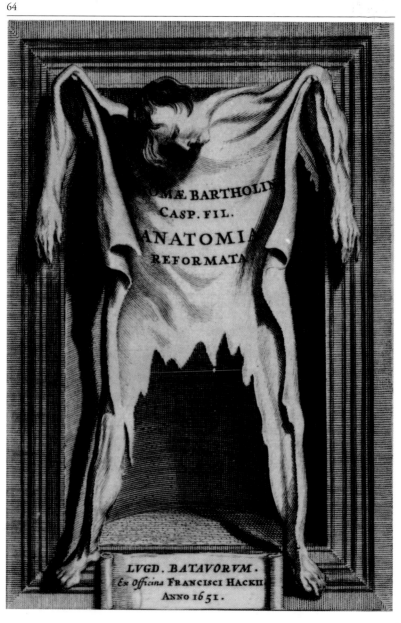

OMÆ BARTHOLIN
CASP. FIL.

ANATOMIA

REFORMATA

LVGD. BATAVORVM.
Ex Officina FRANCISCI HACKII
ANNO 1651.

"I have dissected more than ten human corpses, digging deep into each limb, pulling back the minutest bits of flesh…If this subject excites you, you may feel a natural repulsion, or even if you're not put off, you may still dread spending the night among cut-up, flayed, ghastly-looking cadavers. If all that still doesn't deter you, you may lack the artistic talent indispensable for this science."

Leonardo da Vinci,
The Notebooks, probably c. 1510

CHAPTER 3
AT THE HEART OF THE BODY

Left: the frontispiece to a 17th-century anatomy book by Thomas Bartholin (1616–80) whimsically displays its title on the flayed skin of a man. Right: on an ancient mosaic from a house on the Appian Way in Rome, a body whose skeleton is crudely visible reclines above the familiar Socratic Greek saying: "know thyself."

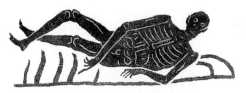

ΓΝШΘΙ·ϹΑΥΤΟΝ

We have always felt reluctant to cut open our fellows. If we manage to overcome this resistance, it is not always in order to improve our knowledge of anatomy. The Egyptians emptied the abdomens and skulls of the dead to embalm them, but they hardly indulged in the comparative study of organs. In Greece, the oracles who sifted through the entrails of cadavers to read the future of the living did not care about the formation of the digestive tract. Similarly, human sacrifice and cannibalism have nothing to do with rational investigation: extensive knowledge of anatomy is of no particular use in rendering offerings to the gods or preparing a roast.

Medical knowledge of the human body was long restricted to what could be observed externally. Among the ancients, the most celebrated physician of Greece, Hippocrates, never opened a cadaver, nor did he leave any treatises on the subject. Doctors rarely performed dissections, and those anatomical descriptions that do survive are sketchy

The oldest known anatomical illustrations in the West were those of Herophilus and Erasistratus, anatomists working in 3d-century BC Alexandria who are credited with having performed dissections and even vivisections. They are the source for a body of very schematic figures that were preserved until the late Middle Ages. Opposite: an illustration of the muscular system from an 11th-century Arabic manuscript of the great medieval Islamic scientist and philosopher Ibn Sina (known as Avicenna, 980–1037) is probably based on the Alexandrian series. Left: a picture from a 1345 medical treatise by Guy de Pavia is less crudely executed, but the two flaps depicting the opened walls of the abdomen look more like book pages or bits of Gothic architecture than anatomy.

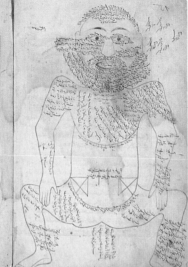

at best. Aristotle devoted a great deal of study to the natural sciences, composing a *History of Animals* that comprised a collection of anatomical sketches—perhaps the first in history. He noted that the internal parts of a human must necessarily remain unknown: "One can only imagine them by their evident resemblance to the organs of other animals." Knowledge based on analogy dominated most Classical medicine. In the 2d century AD, the great Roman authority on anatomy, Galen of Pergamum, whose works influenced the West to the end of the Middle Ages, advised his students to learn anatomy by examining "monkeys, who most resemble man." Thus, knowledge of the shape and function of organs was the outcome of a peculiar compromise. Though the exterior appearance of human beings was well known, the skeletal structure was simian, while the viscera were often those of a dog or pig.

Medicine encounters art

Medical studies continued to follow ancient

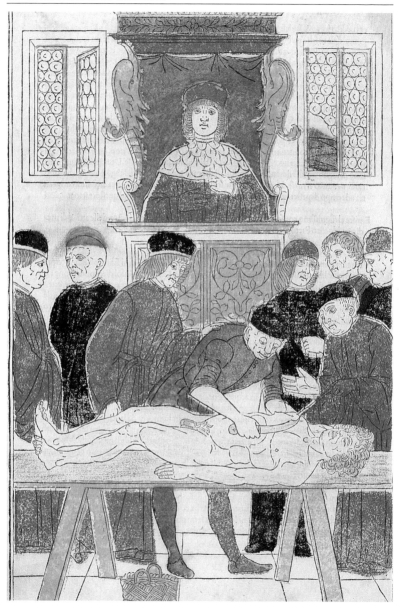

precepts, rather than empirical research, until well into the medieval period. In 1230, the Holy Roman Emperor Frederick II delivered a famous edict banning the practice of medicine without one year's prior study of anatomy on the human body. Two papal excommunications against the author of this bold decree were not enough to put cadavers back in their graves. A century later, the church faintheartedly issued its first dispensations, and little by little a reliance on dissection became widespread in Europe. As theology and the sciences gradually shifted humanity's position in the world away from its supreme place, human beings wanted to see themselves fully, and to establish for themselves a fixed standard of measurement.

Opening human cadavers, students began in-depth investigations of anatomy, while at the same time elevating to highest status the part of ourselves that remains forever hidden from view. The more we learned about the body, the more mysterious and exotic became the soul. Death held the invisible truth of humanity.

This picture from John Arderne's *De Arte phisicali et chirurgia,* c. 1412, attempts to show internal organs as they appeared in a dissection. Cut into halves vertically, the body appears as an open book. Opposite: an anatomy lesson illustrating Johannes de Ketham's *Fasciculus medicinae,* the first printed medical treatise, published in Venice in 1491.

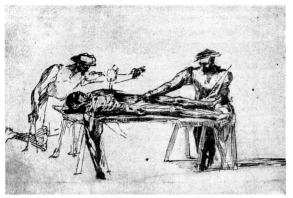

Left: a 16th-century drawing presents dissection as a genre scene. Note the candle planted conveniently in the corpse. Below: Ligier Richier's remarkable tomb sculpture (after 1544) echoes an older medieval tradition of personifying death.

But an anatomical examination—however rigorously conducted by the physician—was destined to be forgotten if it was not depicted in an image. Thus, as the distaste for autopsy dissipated, so too did proscriptions against anatomical illustration, and by the 14th century, a new generation of physicians undertook dissections in close collaboration with artists.

Using the invisible to explain appearances

In addition to working with physicians on the illustrations for anatomy treatises, artists also undertook dissections on their own initiative. During the Renaissance, when taste set a premium on naturalistic realism, artists could no longer rely for their knowledge of human forms purely through the study of nude models. Not only was public nudity itself no longer culturally acceptable, as it had been in the ancient Greek gymnasium, but Renaissance artists and scientists shared a zeal to understand the internal workings of their subjects. In the privacy of the anatomy theater, in the semisecrecy of cellars, in the company of cadavers, artists renewed their contact with the nude.

Giorgio Vasari (1511–74), biographer of the greatest Italian artists of his time, noted that Antonio Pollaiuolo, in the mid-15th century, was one of the first painters to excel in depicting the human body. "He understood nudes much better than all his predecessors, because he

had studied anatomy by stripping the flesh from cadavers to get a better look at how muscles worked in bodies."

For a long time death had been seen as an obstacle to examining the body. Now it had become the very condition for objective knowledge. One may be modestly reluctant to reveal the details of a living nude body, a reserve due to the desire a naked body arouses in us. But a body devoid of life does not stir the senses, and the artist is free to observe and analyze it without compunction.

To be sure, artists at the end of the Middle Ages often depicted skeletons, and there was a great vogue in the 14th and 15th centuries for the Dance of Death theme in art, but this had an entirely different objective. Its purpose was ironical, humorous, and cautionary: to bring death to life, so to speak, to show death as a partner with whom the living must dance. But in the Renaissance, the dead body was neither a fearsome specter nor the moral emblem of mortality, but merely a machine that had ceased to function. Its material reality was what commanded attention. For Michelangelo or Raphael, Benvenuto Cellini or Annibale Carracci, the concern was to have complete familiarity with the human body so as to draw a well-executed figure. They explored the interior to master the surface. Seeing and knowing, to the Renaissance artist, were synonymous. Painters and sculptors held that every body in good mechanical

In the 16th century, medical illustration often took its cue from works of art. This print from a 1545 book on dissection by Charles Estienne adapts a picture by Perino del Vaga (1501–47) representing Venus. The illustrator simply inserted a kind of window in the lower abdomen of the goddess to display her peritoneum.

order was perfect in form. Function became a principle of beauty, and knowledge an aesthetic experience.

The scalpel and the pencil

Of all artists, it was Leonardo da Vinci who, in his desire to find a rational basis for beauty, best embodied this fusion of art and science. He called himself an "anatomy painter." He carried out and drew innumerable dissections, but his style was not simply to depict whatever was revealed in the interior of a cadaver—to draw a still life— but to execute a plan, rather like an architect's blueprint. He aimed less to imitate what he saw than to make clear records of it. "You who make the claim that it is better to attend dissections than look at drawings would be in the right if you were able to see in one single dissected subject all the details offered by drawing," he remarked. For Leonardo, translating the body into image was less the documentation of a dissection than the result of an analysis. He brought to bear on this process a formidable knowledge of mechanics, hydraulics, and statics. Observation corrected prejudices. Conversely, a better understanding of the role of an

organ afforded a more exact image. As his notebooks reveal, even when considering an abstract question, Leonardo always accorded drawing preeminence in the expression of his thought. For him, the image—the only universal language—was less the illustration of the report than it was the report itself. He strove to represent what in the core of the cadaver is invisible: structure and function, the body in action. Thus, he drew prescient parallels between human physiology and what we would today call mechanical engineering.

Perhaps the most important of Leonardo's innovations with regard to anatomical studies was his application of the rules of perspective and representation. In the Middle Ages, the body, seen from the outside and superficially, was represented schematically and two-dimensionally. But with the advent of perspective, illustration conveyed the spatial depth essential for understanding the placement and operations of the internal organs.

The fabric of the human body

Surprisingly, Leonardo virtually ignored the two great inventions of his century, engraving and mass printing. Instead, he gathered his acute observations in a random collection of notebooks. Thus, little of his work was disseminated in his own lifetime, and it had limited influence on his contemporaries. The first treatise on anatomy to rival Leonardo's *Notebooks* for range and accuracy was that published in the mid-16th century by the Flemish doctor Andreas Vesalius, generally considered the founder of modern

To make the body intelligible in its minutest details, Leonardo drew successive stages of cross-sections and exploded views. He sometimes rendered these forms as though they were transparent or substituted spindly strings for muscles to show their points of insertion. Among his more than 200 anatomical studies, none shows a complete skeleton or écorché; for Leonardo, analysis surpassed synthesis. Opposite and below: drawings from his *Notebooks*.

observational anatomy. In 1543, at age twenty-seven, he completed the first work on anatomy based entirely on observation and dissection, *De Humani corporis fabrica* (*The Fabric of the Human Body*). In this book he produced the first comprehensive account and illustrations of the human skeleton. Compared to preceding treatises, his innovations are startling: "I inserted pictures in the text that are so realistic that they must appear to students of nature like a dissected body right before them," he declared. The book has some 700 pages and 300 illustrations, engraved with great mastery—probably by Jan van Calcar and perhaps even by Titian. It depicts bones, muscles, and entrails down to the smallest detail. Every carefully scrutinized organ is displayed from several angles. The body is methodically explored from head to toe, from skin to marrow, with a precision never before equaled.

The écorché figures of Vesalius are always part of the visible world, standing in a landscape or, as here, hanging from a rope. There is a tension between the medical approach to the body—which is displayed as it looks in dissection (here, with disemboweled abdomen, dislocated shoulder blade, and muscles in tatters), but gives no hint of the function of the parts—and the naturalistic, "living" poses and contexts.

Some illustrations show the entire skeleton or nervous system; others make use of the écorché, or flayed body (the French word is commonly used), a figure without skin in which the layers of muscles are peeled back successively, from the most superficial layer to the deepest level. Though Vesalius was not the first anatomist to draw an écorché, his were brilliantly clear and informative. Furthermore, the images are attentive to artistic as well as scientific concerns. Standing figures are placed within a landscape that continues as a panorama from one plate to another, rendering these scenes both vivid and rather bizarre.

The hardworking skeletons and melancholy écorchés

in Vesalius's treatise strike living poses (leaning
on a shovel or against a wall), and strive for
the naturalism of breathing men and women.
Nevertheless, they reflect the anatomy of
the cadaver, not that of the living body.
They are static and even a bit limp, in
contrast to the dynamic, tensed
forms depicted by Leonardo da
Vinci. Where Leonardo's drawings
show virtually no morbidity of tone,
the plates of the *Fabrica* cannot quite
stifle underlying references to suffering,
torture, and the fear of death, despite their
great scientific rigor. The body yields its
secrets to broad daylight only in the lifeless figure
of the corpse. Vesalius's entire enterprise bears the
traces of the daring, shocking gesture of plunging a knife
into flesh.

The écorché takes on a life of its own

The plates of Vesalius's treatise met with enormous success
in Europe. Widely
reproduced, they
served as a model for
anatomical
illustrations for
nearly three
centuries.

Vesalius's *Fabrica* is not
only the first great
book of anatomy in west-
ern medicine, but also the
first treatise on dissection
to present method and
instruments. Above: the
brain; below: the dissec-
tor's instruments.

Se alcuno cascasse da alto e hauesse sangue pesto in dosso e cogelato: p̃ farlo dissoluere e spargere nel buomo. Togli tre carboli accesi di quercie e flouagli nel vino biaco e honor dalo ad bere caldo la matia piu volte.

Vnguẽto vtile a chi hauessi li occhi sanguinosi e colati. Togli puluere e rutia grita parte e butiro che ha fato nel mese di magio: pre tre e doi pte de olio de oliuo: dilequali e mescola insieme e spargi la puluere sopra qsti liqri e miscola benfine a tato che si sfreddi.

Lesione di testa cõ maza: o petra o coltello: overo cõ qualũq altro instrumẽto senza alcuna apertura.

Albula nel occhio
Surdita.
Naso tagiata fino ala orobia.
Apostea dieto allorobia.
Macchia bela faccia
Labri vlcerosi
Taglio di vene magior nel collo
Apostema sotti el braccio

Togli semola de frumeto e cuocila e poi agiogi assungia e la empiastro cõ grasso: ponilo sopra li luoghi insiam: ma se questo no giouara allora ragia la corega del capo e guarda fe cvoto alcuno osso di dẽto, i Reste cerca nela lettera. A.

Nota che gñ vn mẽbro e tagliato se deue curare cũ la dialtea: el quale vn guẽto fi fa cosi: piglia fenogreco e seme lino e tre dullo in puluere e spargi qsto puluere sopra el buttiro e laslalo cosi per doi o tre giompere piglia Lerca el resto nela litera. B

Lo apostema suole venire in tre luoghi nel corpo pria cioe dietro alle orechie come nel collo cioe nella region atarse allora se miniuscha la vena cephalia di luno e altra braccio dalla pte sina e sinõ e vechio tanto piu li miniuscha el sangue

Ferita che ba carne putresata intorno nel luna parte in atra
Taglio di stomacho di sigato e de milsa
Ferita sira de la qual e perso el coltello,
Taglio del budello grã del,

Taglio divena doue nõ stagna el sangue,

Trafisision de costa de bãda in bãda
Taglio dil budello grãde
Trafision dil coltello de banda in bãda,
Ferite penetrata ad sibedoi le pte de la e de q

Ferita di la e di qua ferita psondamẽte sira per tutto,
Sacta dela qual el ferro e rimasto nela carne
Rostura a tuto el corpo
Varoli p tutto el corpo

Cõtra ferita sixa o vero psofoa se la ferita butta molto sangue allora bru sa lodice e sanne puluere e butala sopra la ferita o vero togli quella substantia che si rade della carta pergamena e põla sopra tal ferita e ancora chiara de vouo e sa empiastro e ligato sopra la ferita con stoppa de caneua.

Cõtra el taglio bella vene magior nel collo qñ nõ stagna el sangue allora se deue cusire la vena cõ gran diligentia tanto chel non escesi e sacto questo buttali sopra la ferita puoineterorose e põgh sop lo ẽ

piastro e laslisi cosi sino alquarto giorno lo ẽ piastro si deue fare di chiara de vouo con in censo e stopa da poi si medica come le ferite. Ferita streta laqual ba puto busi. Trafision di legno,

Apostema nelle anguinagle,
Sevua ferita sissa sara, p sonda e nõ viscira sangue essendo cauato lo instrumẽto allora deue iacere sopra le ferite ad cio che escbi sangue e le inudicite: e se i tal modo nõ cleissenõ deue sossiar tãto nela ferita sino a tã to che per quel sia to vis raño. Lirca el resto nela littera. E
Ad maturare vno apostema o altra insiadura: slaoci el seme lino in ba tiro: e laslalo cocere sino a,tãto che baste: e evn guento nobile cõtra apostema o altra insiaturar cõsequete mete ad scrite antique rotte.

Cõtra le feride che sono fate da veretone o sagetta: allora nõ se deue tra re el ligno o vero basta bel serreama se ne vscito el legno: e el serro e rimasto dentro: allora si di circare cũ la spatula.

De varoli li quali sono certe vesliche come mel se sogliono hauere li putie: alcuna volta li vecchi ancora le bãno: e sono fati in doi modi cioe rossi o biachi: le sarano bischi si deue imolegare Lirca el resto in sira. L.

Ma se sara la apostema nelle anguinagle allora miuiscasi el sã gue bala vena virgi nale laquale e soto el calcagno e chiamasi scisso empiastrovngila vea mestrovda delle bonne e vera vena virginale,

Contra insiatura di serita piglia incesso e disallo in vna padella: e colalo in alcuno vaso e miscola sino a tãto che verra odorisero: e quã to piu el mischolerai tanto sara meg iore la serita: e in briue tepo sara curata,

Rimedio otro al palterico: e lenguẽto pigla siereibo cõ la sua sofa e mille foglio cõ el suo seme e seme de vrtica e la radice i cõ el seme e cera e assungia,cereba el resto ne la lettera. O.

Contra le veruce : pigla sterebo de cane e bella terra doue ba vrinato e falla cuocere cõ la vrina bel patiẽte e ipiastra sopra le veruce sempe reno pia le veruce sempe reno uandolo e giouera altro anchora para quello mesdesime parin vasnuerbo (cõ li bobemi nouakosi

No clear distinction existed in the Renaissance between medical and artistic attitudes toward the body. Both disciplines were curious about its internal workings, and both wanted accurate and informative images of it. Far left: an atlas of wounds from the 1491 *Fasciculus medicinae* of Johannes de Ketham. This book included no muscular écorchés. Rather, piercing, lancing, and opening up of the body are illustrated here as traumas inflicted by swords, daggers, maces, knives, and arrows.

Center: a Saint Sebastian painted by the Italian Renaissance master Andrea Mantegna (1431–1506) in the same era renders essentially the same subject as a work of art and religious devotion. Near left: a contemporary target for gun practice conveys some of the same concepts schematically. Invasions of the body are not always the work of scientific dissection.

Left: in 1747 the German physician Bernard Siegfried Albinus (1697–1770) published another exemplary book of anatomical illustrations. He too placed his écorché figures in realistic landscapes, sometimes with whimsical or macabre effect. The rhinoceros in this plate was a rare beast at the time. Its thick skin reminds us of the barrier that had to be pierced to lay bare the human machine. Below: a bronze écorché statue, c. 1600, known as the *Bella Notomia* (the Lovely Anatomy), by Ludovico Cigoli (1559–1613), famed for his technical mastery of the wax anatomical écorché.

Throughout that time, with rare exceptions, the tradition emphasizing the morbid character of anatomical knowledge was perpetuated. Illustrators occasionally became ghoulishly interested in detail, showing the pins and rods that kept the body in place, the needles and threads that moved tendons, sometimes even the flies that fed on the dead flesh.

Parallel to this largely medical tradition was a course followed by artists from Michelangelo to Jean-Antoine Houdon (1741–1828) that might be called "living anatomy." In addition to the printed treatises on the body intended strictly for painters and sculptors, with drawings and written descriptions, they sought to create

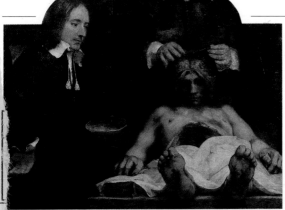

By cutting the body into pieces, dissection undermines the principle of unity implied by the notion of the "individual" —a word that means "indivisible body." Thus, research dissections must be distinguished from autopsies performed on respectable citizens to determine cause of death. From the medieval period through the 18th century, the cadavers available for dissection were usually those of executed criminals, that is, detached members of the body politic. Such dissections were not illegal, but were considered distasteful, and were practiced behind closed doors. In the 17th century, this tendency began to be reversed, and physicians performed anatomy lessons for popular audiences as well as students. Indeed, the medical amphitheater rivaled the theater proper, as dissection became a fashionable spectacle. Above: Rembrandt's 1656 *Anatomy Lesson of Dr. Joan Deyman* was, like other 17th-century paintings of dissection, commissioned by a medical school. Far from trying to reproduce the dead appearance of a cadaver, many artists drew or sculpted écorchés with the posture and muscle tone of a living body. Their anatomical models were intended for artistic as much as medical study of the human form.

models in the round: the écorché proper, usually made of modeled and colored wax, or painted wood, papier mâché, or plaster. The three-dimensional écorché converts a simple narrative image that describes a dead body lying broken on a dissecting table into a far more complex image in which something resembling real life is created synthetically.

The écorché deals in appearances, but reveals something else as well. In defiance of the diversity of forms, shapes, and colors that human beings have, it presents a "typical" body, and proves that beneath the skin all human bodies look very similar. In exposing the underlying order of muscles, bones, nerves, and organs, it also peers into the invisible common core of all bodies—what we might even call the soul. Whereas dissection illustrations usually present a specific cadaver, the écorché sheds all the signs that characterize a particular, individual identity. Without its flowing tresses or mustache, birthmarks or fingerprints, shorn of skin and fat, sometimes unsexed, the écorché body proclaims itself abstract, impersonal, exemplary. One model fits all.

The image on trial

In the great medical works of the late 18th century, the art of illustrating the dead body achieved near perfection. Luxuriating in minutiae, artists overlooked no fascinating aspect of the opened body. With a consummate skill worthy of the best painters of their time, they excelled at

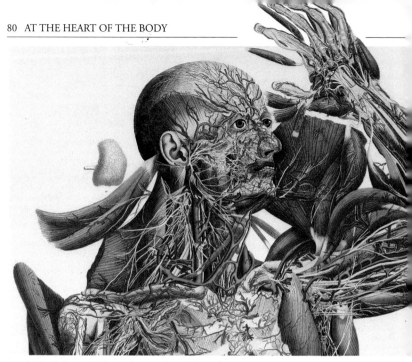

rendering observed fact: the mother-of-pearl transparency of tendons, the glistening fibers of muscles. In an age that celebrated realistic accuracy, the realism of these sculptures and plates was still shocking. The subject matter remained balanced between the beautiful and the grotesque, and the almost exasperating detail rendered the images as difficult to interpret as the body itself. The eye, dazzled by the wealth of information and the brilliance of the rendering, does not know where to look.

This excess of precision reinforces the disturbing strangeness of the image of the flayed body, rather than exhausting all its mysteries. Physicians protested against these queer, yet surprisingly popular, pictures and waxworks, denigrating them as morbid freak-show distractions. In 1801, the French physiologist Xavier Bichat (1771–1802), a pioneer in pathological anatomy, complained in his unillustrated *Anatomie générale* (*General Anatomy*): "What is the point of all these exaggerated descriptive details?…This mode of description is

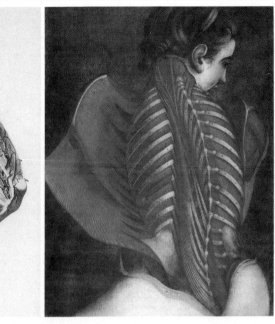

By the 19th century, the expertise of anatomical illustrators and printmakers had reached a remarkable level of precision and expressiveness. Far left: in this life-sized plate from a treatise by Paolo Mascagni (1755–1815), *Anatomiae universae icones* (*Images of Universal Anatomy*), the body seems not so much flayed as exploded.

Near left: this is one of the best-known plates by the 18th-century anatomical artist Jacques-Fabien Gautier d'Agoty. The woman's back muscles are detached in parallel from their spinal insertions and arrayed outward, like wings, giving her something of the appearance of an anatomical angel. The artist wrote in his commentary on this image, dated 1746: "For the dissection of the muscles shown in this plate, we used the body of a woman, since female muscles are more delicate and take up less space, and by this means we were able to give more extension to the figure; we left the head to make the sight more pleasing."

For an artist, anatomical drawing is rarely an end in itself. To study the body's interior is a means of learning accurate draftsmanship. Opposite below: a 1992 sketch by the author.

foreign to the progress of medicine." The implication is that the art of seeing no longer coincides with the art of knowing. The dissected cadaver reveals nothing of the living mechanism. The doctor dismisses the artist.

Today, anatomy textbooks used by students are illustrated, but their pictures offer little to get excited about, except in their platitudes. These are purely technical works. The plates, following international norms, present the body in standardized postures, reference poses mostly inherited from descriptive geometry—front, profile, cross-section—and use an equally conventional system of colors. To the lay viewer, such images are a network of lines and spots suggesting less a human body than a geographic map, which, if it fails to offer the picturesque pleasures of a landscape, at least allows us to find our way effectively around the place.

The body transparent

This criticism of the image persisted through the 19th

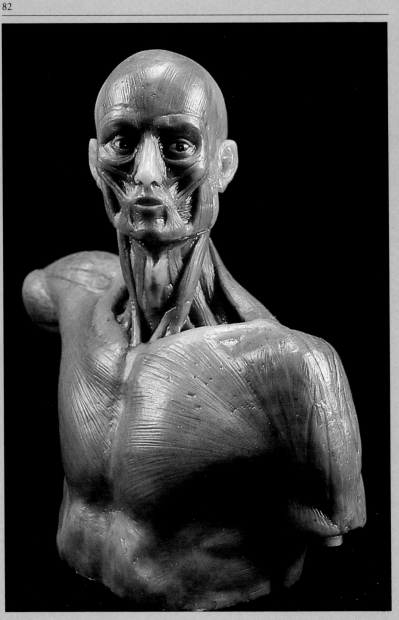

Flesh of wax

One of the great difficulties of dissection is that the cadaver does not long remain in good condition. Lacking an effective process for preserving cadavers, scientists of the Enlightenment era hit upon ceroplasty, or wax sculpture. The figure was molded from a cadaver, then refined from drawings and notes. Wax is malleable and takes detail well, and it can be colored to approximate the tones of skin, muscle, and vessels with startling verisimilitude. The first anatomical wax models appeared in Italy at the end of the 17th century; developing mainly in Bologna and Florence, the technique quickly became popular elsewhere in Italy and France. Scientific curiosity alone did not justify the morbid extravagance that characterized these works, which are perhaps the most extreme representations of the anatomy of cadavers before the birth of photography. Among the most renowned practitioners were Clemente Susini (1754–1814) and the husband-and-wife team of Anna Morandi Manzolini (1714–74) and Giovanni Manzolini (1700–1755). Far left and on page 85: works by André-Pierre Pinson, c. 1780; near left and following pages: works by Francesco Calenzuoli (1796–1829), from about 1820.

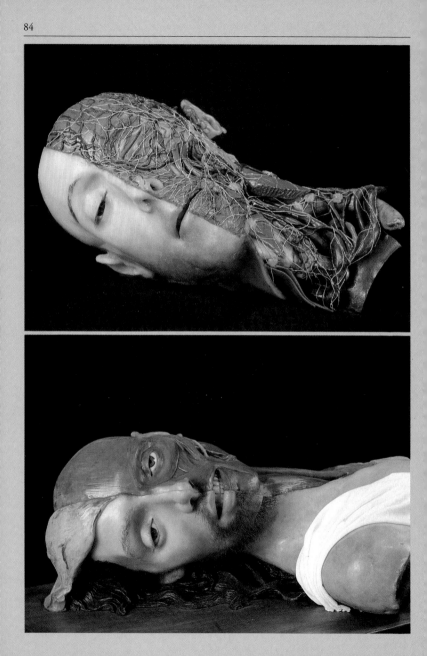

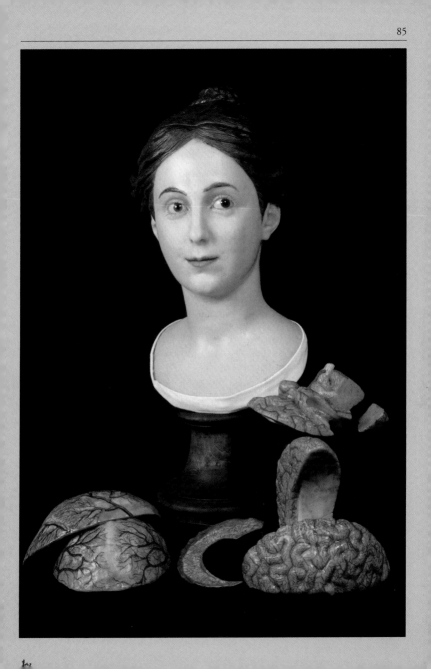

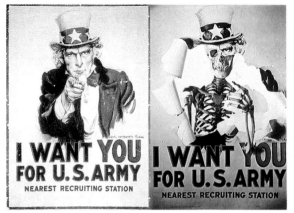

During World War I, a pacifist campaign satirized the classic American army-recruitment poster by X-raying Uncle Sam. It drew upon the traditional theme of the skeleton as memento mori: symbol and warning of mortality, plus the theme of truth hidden beneath the surface.

Below: executed in synthetic material, adorned with blinking lightbulb, *The Man of Glass* was photographed here in 1930 with its creator, Franz Tschackert.

century. It was contemporary with the development of a new research tool, the clinical examination, which provided direct observation of the live patient. To the practiced eye of a physician scanning a body, the opaque skin is no more than a diaphanous veil, revealing more than it hides of the organism within. In 1895, a German physicist, Wilhelm Röntgen (1845–1923), satisfied this yearning for corporeal transparency in a spectacularly concrete form: by discovering X-rays. The interior of the body could now be seen without its being opened or even touched.

If the discovery of radiography revolutionized the medical view of the body, few scientific images have had as great an impact on the popular imagination. In a flash, the magical X-ray rendered normal what had once been macabre. The skeleton was no longer monop-olized by spiritualists; henceforth, anyone could take a look at his or her bones, or entrust them confidently to inspection by another person. At one point, radiologists even elected their own Miss Skeleton. The most intimate of privacies could now be invaded in semi-darkness, and flesh became a stained-glass window.

The theme of the body made transparent inspired countless variations during the first

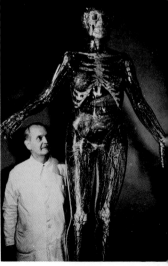

half of the 20th century. For example, in 1915 Marcel Duchamp painted machinelike, partly transparent figures representing a bride and a group of bachelors on a large pane of glass. This existential curiosity about the inner body reached its peak in 1930, when the German Hygiene Museum in Dresden created an artificial mannequin whose transparent skin showed the skeleton and some of the internal organs; this Man of Glass mesmerized millions of visitors to the 1937 Paris World's Fair and subsequently drew crowds in Berlin, New York, Moscow, and Beijing. Revived by Nazi racial propaganda in connection with the theme of hygiene, this sculptural idol was converted into an emblem of the supposed "perfect" human being, uniting the traits of bodily transparency and racial purity.

"The charm, the only true charm, is epidermic: who would think of praising his Dulcinea's skeleton?"
Julien Gracq (born 1910), *En lisant, en écrivant* (*While Reading, While Writing*), 1991

Developing instruments to see inside the body was no simple matter. Until the 19th century, optical devices, even the most familiar, were viewed askance by doctors. Xavier Bichat wrote of the microscope in 1801: "When gazing in the dark, everyone sees in his own fashion." Knowledge beyond the reach of the naked eye was suspect. But by the end of the 19th century, the discovery of radiography overcame the skepticism of the medical profession. Left: a 1914 X-ray demonstration.

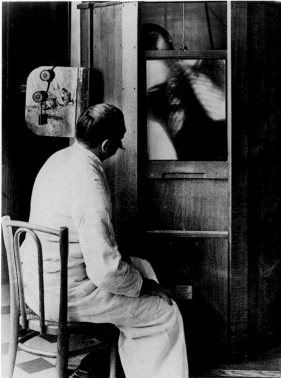

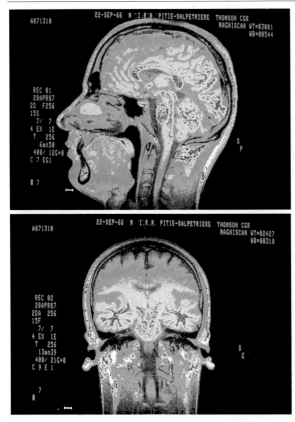

It was an English engineer, Godfrey Hounsfield (born 1919), who improved upon the X-ray with his 1971 invention, the computerized tomodensitometer, commonly known as a CT or CAT scan. This machine compiles a set of cross-section images of the body, taken from several angles, but, like classic radiography, differentiates only soft tissue from hard. The next improvement was in nuclear magnetic resonance imaging, or MRI, which reveals not only the topography of the organs, but also certain functional disturbances. These techniques, and others like them, have brought about the conceptual shift from a qualitative image, primarily morphological, to a quantitative image that directly furnishes parameters of diagnostic value. Contemporary medical imaging is the final stage in anthropometry, virtually reducing the body to a series of numbers. Left: MRI scans of sagittal and frontal sections of the head.

In literature, radiography quickly acquired a figurative meaning. In the novel *Le Temps retrouvé* (*The Past Recaptured*), Marcel Proust used it as an expression of his own form of depth psychology: "The apparent, copiable charm of people escaped me…It meant nothing for me to dine out in town when I did not even see the other guests because, thinking I was looking at them, I was X-raying them."

The eye of the machine

Radiography makes the body transparent to the eye of the doctor while maintaining its formal, functional integrity. Medical imagery today offers a vast palette of

instruments—scanner, endoscope, magnetic resonance imaging (MRI)—to provide direct knowledge of the dark interior without invasive procedures. It is possible to view the thorax in cross-section, follow the topography of blood vessels, make a relief map of the density of tissues, or, in a live projection, follow on a video screen the consumption of glucose in the brain while the patient recites multiplication tables, without any rupture of organic unity. Submitting to the vibrations of waves, permeated by radioactive rays, wrapped in a magnetic field, the body interacts with the invisible to make itself ever more visible. This new generation of imaging tools personalizes anatomy by making medical portraits that are individual and evolving—no longer the picture of the body in general, but that of one body in all its vital particularity.

From inner body to surface exposure

The corpse was a natural subject for making images of the body. It was permanently immobile, inanimate, concluded. Drained of life, it was drained of personality, and even of human meaning. It was as static and fixed as a drawn image. As inert on the

In the first century of its existence, radiography has little by little refined its methods and diversified its uses. But the process remains fundamentally the same, that of the shadow puppet, in which images are obtained by means of a source of radiation external to the body. Conversely, in scintigraphy, the source of radiation is placed within the organism itself. The patient absorbs radioactive substances so that the inner body becomes the emitter of the signal. This image shows the organs from the inside out, emphasizing certain structures of the human body that otherwise remain invisible. Left: a full-body scintigraphic scan.

"The structure of the human body far surpasses in artifice anything human art can build." Baruch Spinoza (1632–77), *Ethics*, 1673 (posthumously published, 1677)

dissecting table as in the illustrative plate, the cadaver seemed tailor-made for conversion into imagery. It is no accident that anatomy textbooks developed roughly in tandem with the use by artists of posed models. Today, the anatomical image has been freed not only from its sometimes unsavory association with corpses, but has nearly divorced itself from the body entirely. It has entered the era of virtual representation and computer simulation. The image no longer directly represents the body, but depicts an abstract concept.

The latest developments in medical diagnostic imaging show that an image no longer need be realistic or literal to be effective. There is no need to ape the human being in order to under-stand its mechanics. Ultrasound, the echocardiogram, scintigraphy, and tomography ignore the form of the organs and their real colors. Traditional perspective, with its vanishing points and its foreshortenings, is replaced by a way of seeing whose syntax is entirely new and self-contained.

From the classic radiograph (left) to thermography, which shows differences in temperature on the body surface (above), medical imaging exploits all the resources of technology. Opposite: a simple method based on the projection of luminous grillwork allows the visualization of bodily asymmetries. As on a topographic relief map, the human body's masses appear in curves tracing each level—in an image that might have pleased the Post-Impressionist painter Paul Cézanne, who wanted to "wed the curves of women to the shoulders of hills."

The first two techniques use sound waves to create images of organs and view organ function in real time; scintigraphy images radiation sources in the body; MRI, or magnetic resonance imaging, is mainly used for creating images of soft tissues (which X-rays do not image well). A magnetic field is created that coordinates the spin of hydrogen ions. When the magnetic field is removed, the relaxation of spinning is measured. PET, or positron emission tomography, measures organ metabolism, creating its image from glucose in the body that has been radioactively labeled so that the scanner can read it.

We may say that nothing is more enigmatic to our eyes than what lies beneath the surface of our own body, for we cannot grasp its complexity except by reducing it to a play of simple surfaces, immediately intelligible. The paradox of the image resides in this: that we have knowledge of our depths only by way of planar images, whether a flat drawing in a book or the surface of a video screen. "The deepest thing," said the poet Paul Valéry (1871–1945), "is the skin."

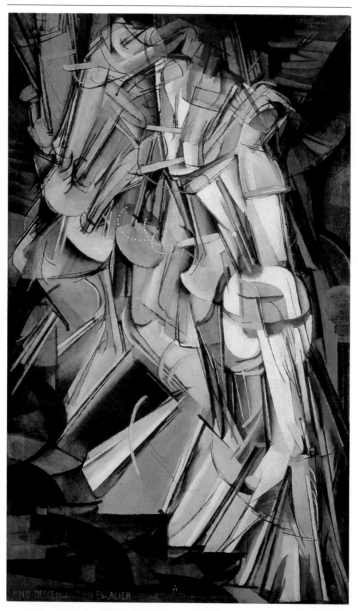

It is by combining successive attitudes into a single pose that a work creates the illusion of movement: "If people in photographs, caught in action, seem suddenly frozen in midair, it's because all the parts of their body are reproduced in the same precise fortieth of a second. And so they lack the progressive unwinding of a gesture that we find in art."

Auguste Rodin, 1911

CHAPTER 4
AUTOMATED BODIES

The body in motion is expressed as a transformation, from one shape to another, one position in space to another. Left: Marcel Duchamp's 1912 painting *Nude Descending a Staircase*. Right: Pinocchio, the wooden puppet in Carlo Collodi's 1882 story who came to life, but longed to be a real boy.

The tradition of "living stones" is ancient. Some dolmens or menhirs—those giant rocks erected thousands of years ago—are reputed to speak or move of their own volition. Blurring the distinction between inert and animate matter, these mobile or talkative megaliths constitute the oldest form of robot. Today's cybernetic robot or science-fiction android wields an arsenal of skills that are far more spectacular. Even when the image of the body in motion is modified by technology, its mythical power—the power to give life to manufactured creations—remains undiminished.

Living statues: a basic belief of the antique world

In ancient Egypt, an effigy of the god Amun was expected to designate the next pharaoh by pointing its finger toward whichever of the male heirs seemed most qualified to rule. In ritual processions, other statues marched or shook their heads. Some of these moving statues were powered by mechanical systems, others by pulleys. The 5th-century BC Greek traveler and historian Herodotus describes the festival of Osiris, in which women walked through the cities carrying "articulated statuettes, about a cubit long, which were moved with strings."

In ancient Crete, the semilegendary craftsman Daedalus, famous for having built the labyrinth that housed the Minotaur, was also said to be the creator

This 8th-century BC Greek terracotta statuette of a woman is called a "bell idol." Its legs, attached under the dress, are the bell's clapper, and the neck and head are the handle.

of Talos, a bronze statue animated by a fluid that circulated through an internal tube, or vein. Plato says that Daedalus's works had to be tied up at night to prevent them from escaping. (The practice in antiquity of tethering statues arose from the superstitious fear that they might actually run away, and was also intended to demonstrate symbolically that they belonged to a particular place.) Ancient literature from China, India, and the Arab world also frequently mentions mechanical marvels such as singing birds.

Whether activated by ropes and weights or merely by imagination and credulity, the living statue reflects the culture that invents it. It is no coincidence that Greek tradition identified the architect of the labyrinth with the father of robots. Daedalus controlled the mazelike palace of the Minotaur just as he controlled the mechanics of the statue. There is an analogy between the place where a visitor walks in circles and the machinery that drives a statue to repeat gestures cyclically. The automaton is not merely a statue equipped with an internal mechanism; it is simulacrum of a human being and a projection of human actions in surrounding space. Its ambitions as well as

Ancient texts describe large animated statues that were used in religious processions or to deliver oracles, but few fragments of these survive (for example, a head of the Egyptian god Anubis with a movable jaw, now in the Louvre). However, many small statuettes have been found that were jointed, usually at the shoulder but sometimes at the hip and knee. Most of these were discovered in tombs, and were probably intended to accompany the deceased into the afterlife. Left: a Greek 4th-century BC articulated figurine. Below: others were no doubt simple toys, such as this Egyptian Middle Kingdom statuette representing a baker kneading dough.

its limitations are embedded in its gears and pivots. The robot reflects the intimate labyrinth of the body as well as the great engineering of the universe in which it moves.

The body caught in the gears of time

The moving statue is cousin to the puppet, the mime, and the clock, and was long an instrument of religion as well. In the hands of the thaumaturges, the miracle-makers, its symbolic prestige made up for its mechanical shortcomings. In the Middle Ages, articulated Madonnas

In a *Treatise on Automata*, Hero of Alexandria (1st century AD) recorded studies of theater machinery in which sets and statues were activated by counterweight-and-pulley devices and hydraulic and pneumatic systems. Left: a drawing reconstructing one of Hero's descriptions. However, the sculptures frequently described in ancient literature as perspiring with anxiety, avenging a death, running away at great speed, or collapsing at the sound of a threat are the result of a bit of engineering mixed with a great deal of legend. Such was the Manducus, a statue said by the Roman authors Plautus (c. 254–184 BC) and Juvenal (c. AD 55–c. 127) to devour children. An ancient marble statue in Rome, from the 3d century BC, popularly named Pasquino, was said in the Renaissance to express his political opinions verbally (in diatribes called pasquinades), and to argue with several other talking statues around the city, in the so-called Congress of the Witty. He is still standing in Rome and is still said to speak.

and Christ figures operated by celebrants were used to portray the Good Friday Passion in ceremonies and processions. In 1352 a clock was built in Strasbourg Cathedral that had a crowing cock. In the 16th century, priests of the Theatine order enlivened sermons with small marionettes, manipulated in full view of the congregation with no intent to deceive.

In the profane world, however, what mattered was the ingenuity of the artifice: it was essential that the spectator not see the mechanism that moved the creature, so that the machine could maintain the fiction of having a free will. The trick for inventors was to find a mechanical means of simulating spontaneity. However, a robot can mimic life only if its mechanism is both precise and fine enough to escape detection. Thus, early in its career, the automaton left the blacksmith's forge for the nimbler workshop of the clockmaker.

The soul of the robot

It was the French philosopher René Descartes who saw the human being as a living robot, reversing the terms of the relationship between the person and the image of the person. Looking out his window at

Mechanical clocks made their appearance in Europe at the beginning of the 14th century. Many of the oldest had chimes in the shape of a bell adorned with a statue of a human figure, called a jack, who struck the hours with a hammer or weapon. The mechanism of these figures was aimed less at producing a spectacular movement, such as the walking statues of antiquity or later automata, than at articulating a repeated, regular action. One of the earliest jacks was made for Norwich Priory in England in 1322–25 and is said to have had 59 figures in processions, with music and bells. A surviving early mechanical bell-ringer is Jack Blandiver, a seated figure in the 1390 clock at Wells Cathedral, in England, who kicks bells with his heels to chime the hours.

The Italian mathematician and astronomer Giovanni Alfonso Borelli (1608–79) wrote *De Motu animalium* (*On the Movement of Animals*) in 1680, a study of the mechanics of muscles. In this treatise he tried to apply Galileo's analytical method for the study of mechanics to physiology. He was the first to notice that the human body, like celestial bodies, has a center of gravity, which defines its balance. Left: diagrams from his text.

A drawing c. 1570, by Carlo Urbino, based on a study by Leonardo da Vinci of the body in motion.

passersby in the street, he remarked: "What do I see…but hats and coats that cover ghosts or simulated humans, which move only by springs?" Descartes saw the robot as a model for the living organism (which he called an "organic machine"), a creature who stands at the point of tension between being and seeming. In his *Traité de l'Homme* (*Treatise on Man*), written in 1633, he designed a self-propelled android, using alembics,

bellows, pipes, and valves. He built this device, an acrobat called Francine, in about 1640. Descartes was nonetheless persuaded that the soul is a reality that cannot be reduced to pistons and cogs. He wrote in his *Discourse on Method* in 1637: "[We may] look upon this body as a machine made by the hands of God, which is incomparably better arranged, and adequate to movements more admirable than any machine of human invention. Were there such machines exactly resembling in organs and outward form an ape or any other irrational animal, we could have no means of knowing that they were in any respect of a different nature from these animals; but if there were machines bearing the image of our bodies, and capable of imitating our actions as far as it is morally possible, there would still remain two most certain tests whereby to know that they were not therefore really men…They could never

"Borelli, it is true, tells us why a person thrown off the center of gravity will fall; but he does not explain why, very often, a person does not fall."

Honoré de Balzac,
Théorie de la démarche
(*Theory of Walking*),
1833

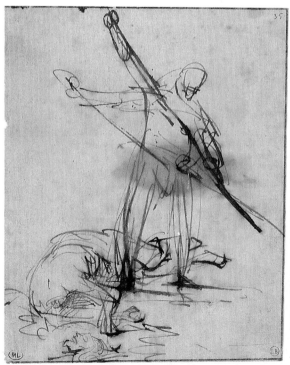

Left: this drawing by Rembrandt shows the beheading of Saint John the Baptist, sketched with evident speed and great dynamic energy. The scene is composed of the two successive gestures of the executioner, unsheathing and then resheathing his sword. Between these two actions is the unseen act of assassination, which leaves the body of the saint prone on the ground. The image is given life by the artist's refusal to freeze the figure of the swordsman within the precise boundaries it occupies at a given instant. Similarly, the great Italian Baroque sculptor Gianlorenzo Bernini (1598–1680) asked his models to keep moving. "The human being," he said, "is never truer to himself than when he is in motion."

"Why does a fine sketch please us more than a fine painting? Because it has more life and less form. The more you introduce forms, the more life disappears."

Denis Diderot,
The Salon of 1767, 1767

use words or other signs…
[to express] thoughts, [and]
although such machines
might execute many things
with equal or perhaps greater
perfection than any of us,
they would, without doubt,
fail in certain others from
which it would be discovered
that they did not act from
knowledge, but solely from
the disposition of their
organs. Again, by means of
these two tests we may know
the difference between men
and brutes."

But some of his followers
were inspired to explore
further the difference
between a human and a
constructed body.

From aping humanity to explaining it

The 18th century—age not
only of the Enlightenment,
but also of mannered
politesse and affectations, clockmaking and mechanical
dolls—saw several attempts to fulfill Descartes's robot
dreams. At Schloss Hellbrunn in Austria there is a mechan-
ical theater with 113 automata, built c. 1750. Philosophers of
the time were eager to explore the relationship of the motor
action of the body to emotions. A French physician named
Julien de La Mettrie (1709–51) sought mechanical explan-
ations for all human activity and behavior. He caused a
scandal by declaring that the soul died with the body, and
in 1747 wrote a provocative essay titled *L'Homme-machine*
(*Man a Machine*). Followers of the theories of Descartes
included the partisans of a discipline called "iatro-
mechanism," the forerunner of physiology. They saw the
mechanical model as the universal key to an understanding
of the human body. Inspired by this belief, Jacques de

"The human being is
only an animal, or an
assembly of springs all
wound up by one
another…Human beings,
eager though they may be
to elevate themselves, are
really no better than
animals or machines
crawling vertically."
Julien de La Mettrie,
L'Homme-machine (*Man
a Machine*), 1747

Vaucanson (1709–82), a mechanic from Grenoble, part huckster, part scientist, sought to demonstrate the vital functions of the body with automata, called "moving anatomies." His first invention was a life-size flute player. Unlike other robots of the period, which were equipped with a concealed music box, this fellow moved his fingers and blew tunes from his instrument. Public reaction was dramatic: music lovers and curiosity seekers jammed the android's recitals of minuets and other dance tunes. Vaucanson made two other robots, including a famous 1738 duck with 1,000 moving parts, which could flap its wings, quack, ingest food, and defecate. In 1741 he submitted a grandiose plan to the Académie of Lyons: to manufacture an artificial human being, "an automaton whose movements will imitate animal actions, the circulation of blood, respiration, digestion, the play of muscles." The minutes of the Académie added: "The author claims that it will be possible, by means of this automaton, to conduct experiments on animal functions and to infer certain conclusions for knowing the different stages of people's health in order to provide remedies for their ills."

While Vaucanson's plan was never carried out, his research encouraged other mechanics, such as the Swiss Pierre Jacquet-Droz (1721–90) and his son Henri (1752–91), to construct ever more ingenious performing automata. Their masterpiece was the 1773 Musician, a young lady who played the keyboard and even appeared to breathe. Other inventors went even further, creating speaking robots capable of articulating vowels and phonemes. The animated statue of the Enlightenment, unlike those of antiquity, offered no lengthy oracles, but modestly recited the alphabet. It gave up its mystical role in aid of scientific

Opposite: the belly of Pierre Jacquet-Droz's 1774 automaton, the Little Writer, opens to reveal its gleaming brass innards.

Despite many legends around the world of speaking and singing statues, the first attempts to re-create the human voice artificially occurred in the 18th century. In the 1770s, in Vienna, Wolfgang von Kempelen (1734–1804) succeeded in producing a few phonemes with a "speaking machine." Below: a device from the early 20th century, triggered by a pneumatic system and equipped with rubber lips, was able to synthesize vowels.

research. Nevertheless, its association with the realm of illusion and phantasmagoria persisted, and the secrets of the body were merely buried more deeply. The automaton may explain how the human body functions, but not how it came into being, nor how it decides its actions. Rational though it may be, it copies effects, not causes. Furthermore, it cannot generate progeny; it requires the existence of a builder and of someone to switch it on.

The body enters the darkroom

If the origin of life remains beyond the scope of the android, another of the body's most spectacular talents has been easier to capture: movement and its corollary, speed. Artists since palaeolithic times have expressed speed in the poses of their subjects. In the 19th century, the French artist Eugène Delacroix (1798–1863) chastised painters who froze their models in long poses, declaring that anyone with skill could seize the essential traits of a body falling past a studio window. But the study of bodies in motion requires great rapidity of perception, and it was the invention of photography in 1839 that finally supplemented the mind's eye and memory with documentary records.

Muybridge, the American artist Thomas Eakins (1844–1916), and Marey showed the world something entirely new: frozen images of a body in action, of which visual memory holds no trace. Above: a Marey chrono-photograph registers a timed series of images of the body occupying successive points in space on a single photographic plate. Dressed in white, the model is made visible by moving against a black background that leaves no impression on the plate. Marey was most interested in analyzing the mechanics of motion of a body in space.

How can multiple shots be caught on a single plate without a loss of clarity where the images overlap? Below: Marey's solution was "to dress the walker completely in black, except for narrow bands of shiny metal aligned along the leg, thigh, and arm." The body is thus transformed into an articulated robot-like figure (overleaf).

Photography is ideally suited to catching a body at high speed, yet it too freezes movement onto the fixed surface of the photographic print. To remedy this, artists and scientists explored ways to create or replicate moving images. The British artist and inventor Eadweard James Muybridge (1830–1904) was the first to use stop-action photography to record bodies in motion in sequences of exposures. In 1872 he photographed a running horse using a set of glassplate cameras whose fast shutters were tripped by the animal's hooves. He soon extended his experiments to pictures of men, women, and other animals in motion, and later projected the sequential glass-plate images on a rotating disk he called a Zoopraxiscope to create what was essentially the first motion picture. In 1882 the French physiologist Etienne-Jules Marey (1830–1904), inspired by Muybridge, made sequences of stop-action photographs on a single plate, called chronophotographs. Marey was less concerned than Muybridge with freezing isolated images of the body in action for analysis. Instead, he was determined to capture movement itself in order to understand and visualize the space covered by the subject, among other phenomena. The chronophotograph did this: the positions of

Left: a time-lapse chronophotograph of a leaping man wearing a black Marey suit. Marey's earlier attempts at sequential photography were made with a "photographic rifle," a device equipped with twelve light-sensitive plates mounted on a rotating disk; the lens was lodged in the barrel. Like Muybridge's system, this ancestor of the movie camera took a series of individual shots very quickly.

A chronophotograph breaks movement down into its constituent segments in a single photograph, but it remains a fixed, immobile image in which motion is suggested to the imagination only in the empty spaces left between instants; it is not visible except as a sort of lattice-work, without continuity. This method nevertheless permitted Marey to supplement his analytical work on the body with images recording actions as successive stages of pure movement.

Left: around 1912, in order to increase efficiency in factories, Gilbreth set out to analyze and control the movements of workers, turning them into living automata. In his studies, a lightbulb was attached to a worker's arm and a simple long-exposure photograph recorded its motion, while the worker's body all but vanished.

Below: a phenakistiscope, c. 1900. When the disk is spun, the white figures appear to be a single running man.

the moving body that succeeded one another in time were recorded in space, as if many people were moving together in perfect synchronicity. Marey's chronophotography and Muybridge's stop-action both deconstruct movement. In essence movement is suggested to the imagination only in the empty spaces that lie between two poses; it is not visible, it is an idea. In Marey's documentary images, gestures and poses disappear, and ultimately, so does

the body. Nothing remains but a fluid, disembodied line unrolling in time and space. Like a shooting star, the human being exists only through its trajectory.

Model conduct

At the turn of the 20th century in the United States, the early efficiency experts Frank Gilbreth (1868–1924) and Lillian Gilbreth (1878–1972) used a method like Marey's to study and control every motion made by assembly-line workers. Hands at machines trace interlocking curves, a complex and graceful calligraphy in three dimensions that the worker must learn and maintain in order to keep the machinery running. Within the factory, workers are reduced to being gears of flesh in a machine of steel. Grim and inhumane as this new science of efficiency was, it was really no more than the modern era's adaptation of Descartes's view of the human body as a sort of automaton. In 1641, he had written prophetically in his *Meditationes:* "As a clock composed of wheels and weights observes not less exactly all the laws of nature when it is ill-made and does not tell the hours as well as when it is entirely to the wish of the workman, so in like manner I regard the human body as a machine so built and put together of bone, nerve,

"Pursuit is the occupation of our whole lives."
William Hogarth,
The Analysis of Beauty,
1753

Left: an illustration from Marey's study *Animal Mechanism,* 1873. The runner holds a recording cylinder connected to sensors on his shoes, which measure his speed, while his cap records vertical oscillations.

muscle, vein, blood, and skin, that still, although it had no mind, it would not fail to move in all the same ways as at present, since it does not move by the direction of its will, nor consequently by means of the mind, but only by the arrangement of its organs."

The robot is the incarnate image of the disciplined body. Ideal when mastered and submissive, it arouses fear whenever its mechanism overheats or spins out of control, or when, as happens often in science fiction, it acquires a mind of its own.

The mechanical brain

From the earliest animated statues to today's robotics, from mythology to cybernetics, the automaton has always inspired conflicting emotions. Although the Renaissance and the Enlightenment embraced the automaton as an emblem of progress and moder- nity, the 19th century began to regard fabricated human replicas with anxiety—the creature of Mary Shelley's 1818 novel *Frankenstein,* for example, represents the dangers of uncontrolled science. The 20th century, in turn, has regarded such creations with a mixture of excitement, pride, and fear. In the years just before World War I, mechanical inventions of all kinds were celebrated—electrical power, the automobile, the speeding train. A group of Italian experimental artists known as the Futurists attempted to depict bodies in motion, as if they were such marvelous

Unique Forms of Continuity in Space, 1913, by the Futurist artist Umberto Boccioni.

machines: running figures and birds in flight became speeding cars, trains, and planes. With the advent of the motion picture, popular culture turned with enthusiasm to science fiction. The futuristic android was often depicted as a frightening figure, an electronic reincarnation of the old medieval wooden or bronze clock jack, or indeed of the Golem, the monster of animate clay of Jewish folklore. Yet at the dawn of the 21st century, science has once again made the robot an admirable creature, using powerful computer programs to construct virtual humans who can crash-test cars and help with the design of homes, hospitals, and airplane cabins.

In the age of the thinking machine, androids have lost nothing of their magical power to fascinate. Where formerly the cry was "Objects! Have you a soul?" today it is "Machines! Are you intelligent?"

Above: the robot created for Fritz Lang's 1926 film *Metropolis.*

"Could a mannequin moved by strings be more graceful than the human body? Yes, no mortal can match a dancing marionette...Grace, without affectation, appears in a figure when it is no longer conscious of its gestures, or when it has just one that is infinite: in the marionette or in God... There, the two extremities of the circle that is the world are joined."
Heinrich von Kleist, *Ueber das Marionetten-theater* (*On the Marionette Theater*), 1805

"In life you were mine, and in death you will remain my wife…Shaped by the skilled hand of craftsmen, your image will be laid out on our bed. I will lie down beside it and taking it in my arms, calling your name, will think I possess my beloved wife, though she is gone—what cold comfort."

Euripides, *Alcestis,* 5th century BC

CHAPTER 5
EMBODYING DESIRE

Left: a drawing by Titian of an embracing couple, seen as a complex network of crisscrossing lines. Right: in the late 19th century, seaside bathing was popular, but propriety dictated that ladies not be seen publicly in the relative undress of a bathing costume. Bathing cabins were an awkward attempt at a solution, as this 1893 lampoon demonstrates.

Phantoms do not have their portraits painted. Vampires show no image in the mirror. Many gods forbid any effigy to be made of them—their immortality is offended by such pitiful mortal counterfeits. Some deities cast no shadow, like the goddess in Richard Strauss's opera *Die Frau ohne Schatten* (*The Woman without a Shadow*), who cannot marry a mortal unless she renounces her divinity in exchange for a shadow that will make her human. Only beings whose likeness can be captured in an image are assured of corporal existence on this earth: no image, no body. It is the privilege of human beings—and possibly their shame—to be portrayed everywhere, to be duplicated brazenly, to recognize themselves in a piece of wood or a few dabs of paint, and to know that the image—this fragile simulation—nearly always outlives them.

Survival by burial

Over the millennia, many civilizations have walled up paintings in funeral chambers and buried sculptures under-ground, offering deathless images as company for the dead. Today, the ancestor's portrait in the hall or the wedding photo on the mantelpiece perpetuates for a while the presence of a departed person and invites us to celebrate his or her life, but in a very different mode. The work of art placed within a burial mound, sarcophagus, or tomb is immured in darkness, visible only to the eyes of the gods. Its purpose is to ensure the happiness of the deceased in the occult world of death, and its meaning is hidden in the enigma of its permanent inaccessibility. In contrast, the publicly displayed photograph of an absent loved one, the commissioned portrait of a family patriarch or scion, the enameled picture of a decedent fixed to a tombstone—these images are

Left: in ancient Egypt, a small statuette of a nude woman was some-times placed in the tomb of a deceased man as his "concubine," ensuring his continuing strength and virility by serving as his companion in the after-life. These sculptures, like all Egyptian tomb art, were intended never to be seen by a living person. They may be said, there-fore, to celebrate the triumph of the idea over the form.

framed, lighted, and exhibited as prominently as possible. Their function is to preserve bodies from extinction, to postpone their ineluctable destruction by keeping them, however imperfectly, in the visible universe.

These two forms of representation correspond, in fact, to two opposing cultures of the image. The first considers the body represented by the image as destined for resurrection; the second places the vanished body in oblivion, under the sign of arrested life. The former is exemplified in the resurrection myth of the Egyptian god Osiris; the latter refers to the death-dealing myth of Medusa, the monster who turns to stone all who see her.

The triumph of Medusa

In Egyptian mythology, Osiris is the god of new begin-

Our culture does not bury its artworks, but on the contrary exposes them to the broadest possible public. Evoking the multiple glances trained upon the work of art, in 1974 Enrico Job made a composite self-portrait of numerous photographs taken from different angles. Assembled in the manner of a planisphere (a flat map of the earth), the resulting figure incorporates a wide range of vantage points, producing an impossible compound of profile and full-face views. Above: a detail of his head.

nings. The guarantor of life on earth, he presides over its renewal in the subterranean world of death. Like the seed planted in earth to be reborn, the body depicted in the tomb is a form of transitory envelope bearing the germ of another life. As a principle of fertility, the image of the buried body merges with that of the genesis of the body.

The gaze of the Gorgon Medusa turned to stone anyone who dared look at her. Below: Caravaggio's *Head of Medusa* is an image of startling realism and

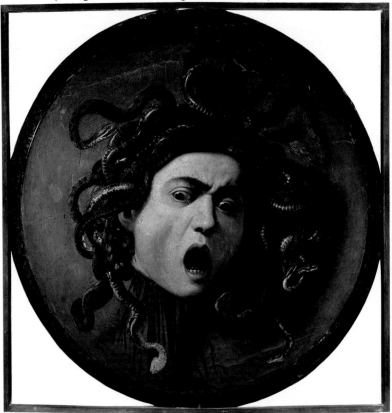

The buried artwork ensures the rebirth of the deceased by representing it in a state of life. Conversely, in Greek mythology, the Gorgon Medusa changes those who look upon her to stone. The artwork does not promise life; rather, it converts the living being, in a flash, into a dead sculptural form, to be enjoyed forever as a beautiful

grotesque horror whose serpent tresses are an indication of her power to transform.

object. Offering us a semblance of eternity, it turns us into a premature corpse. From the Classical Greek statue of the *Doryphorus,* the athletic youth frozen in mid-

According to tradition, the veil of St. Veronica (whose name, *vera icona,* means "true

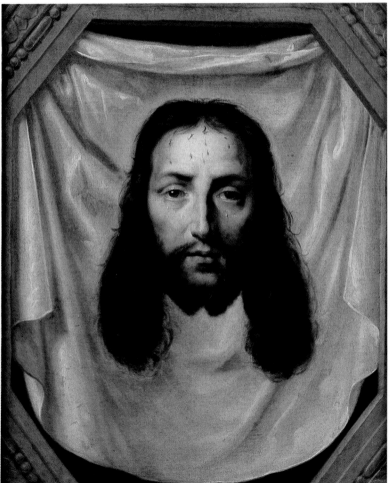

stride, to today's instant snapshot, the image of the body in the western world for the past 2,500 years seems in thrall to the seductive, frightful power of Medusa, rather than dwelling under the reassuring patronage of Osiris.

image") bore the image of Christ. This painting, a representation of a representation, presents Christ's face in icon style.

A body sheltered from watchful eyes

The fear of Medusa's petrifying stare affects many of our daily habits. We often seek refuge from her in modesty, hoping to shield ourselves. How can one escape the gaze of the terrible Gorgon except by hiding one's body, withholding it from this devastating glance?

However, when the body is too well hidden, it becomes the object of every fantastic projection of the imagination. The Enlightenment philosopher Jean-Jacques Rousseau (1712–78) described this problem using the metaphor of a

Pierre Bonnard's *Intimiste* painting of his mistress in her bath presents the body in the cozy isolation of a private world. *Nude in Bathtub*, 1935, with its soft brush-strokes and sensuous colors, suggests more than it describes, despite the revealing pose of the model. The gaze becomes

statue eternally wrapped in an impenetrable veil: "The imagination of its worshipers shaped it for them according to their natures and their passions, and each of them… used this mysterious veil to hide just one thing: the idol of his own heart." The cloaked body is, in its own way, intensely provocative, and the clothes that mask it serve to allow the observer free rein to invent the body beneath according to his or her own desires.

hazy as it penetrates the water.

"Golden rule: leave an incomplete image of yourself."
E. M. Cioran (1911–95), *De l'inconvénient d'être né* (*The Trouble with Being Born*), 1973

From museum to sex shop: the body unveiled

In another Greek myth, the sculptor Pygmalion fell in love with a statue he had carved of a beautiful woman,

and implored the goddess Aphrodite to send him a woman as pretty. The goddess of love responded by bringing the statue itself to life. What is the line between the image that awakens aesthetic emotion and the image that triggers sexual attraction?

One of the banquet

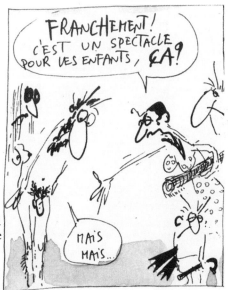

guests in Plato's *Symposium* affirms the existence of two antithetical Aphrodites, one of heaven and one of the earth. Whereas the first sublimates love by exalting its nobility and beauty, the second spurs physical desire by unleashing the obsessive quest for satisfaction. Each has her temple: museums claim to exhibit the heavenly Aphrodite, while sex shops promote the ancient earthly goddess. But as anxious moralists and art critics have often noticed, the two goddesses are less dissociated than they may seem. "The most elevated and the most vile things," the German novelist Johann Wolfgang von Goethe (1749–1832) once said, "are linked to one another everywhere, in the most intimate fashion." Even the purest, most idealized form of the human body can never purge

"All [those] who constantly utter the words 'immoral, immorality, morality in art'…remind me of Louise Villedieu, a two-bit whore, who accompanying me one day to the Louvre, where she had never been, began to blush, covered her face, and pulling on my sleeve constantly, kept asking me, in front of the immortal statues and paintings, how anyone could make a public display of such indecency."

Charles Baudelaire (1821–67), *Mon coeur mis à nu* (*My Heart Laid Bare*), 1887

Cartoon text: "Honestly! Is that a spectacle for children?" "But, but…"

itself totally of eros. Similarly, the most trivial pornographic image, because it keeps the body out of reach, idealizes it by imbuing it with a despotic power to awaken desire.

The nude undressed

Since it is futile to yearn for the favors of a marble Venus, aesthetic pleasure—born, says Sigmund Freud, of an urge inhibited in its goal—circles around its object without ever reaching it. Condemned to long for what it can never fully possess, the spectator—this devotee of the image—struggles both to approach and to spurn the represented body, at once stirring and suppressing desire.

In the academic school of painting of the 19th century, nude subjects were exceptionally popular. Under the cover of elevated Classical and mythological subject matter, scenes of naked men and women, drenched with sentimentality, fulfilled the desires of a culture that clothed bodies heavily and censored the literal nudity of living people. This display of bacchanals—satyrs cavorting with nymphs, wallowing in sensual

Below: The precise subject of Edouard Manet's painting is much debated. It does not seem to depict an Arcadian idyll so much as a frolic in the shrubbery. The painting was rejected by the Paris Salon of 1863, and one critic wrote, acidly: "Manet will have talent… the day he gives up subjects chosen for the sake of scandal." In fact, the scandal relates less to the subject matter (pastoral nudes were a classic theme) than to the artist's refusal to idealize the nude female body. Opposite above: the theme has been widely debased ever since, as can be seen in this cheese label.

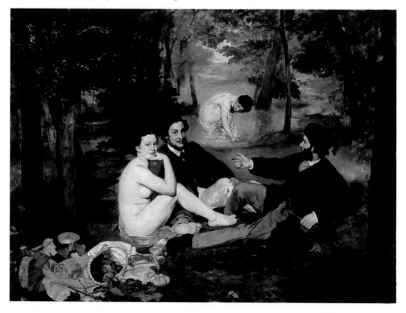

love—flatters and titillates the imagination without affronting a sensibility that enjoys allegory. The public that admired the 1863 nude *Birth of Venus* of the French artist Alexandre Cabanel (1823–89; see page 153) had a totally different reaction to the nude painted the same year by his compatriot Edouard Manet (1832–83) in *Déjeuner sur l'herbe* (*Luncheon on the Grass*). Here the woman's body is no longer deified, but served plain, in a realistic contemporary context, like a sandwich on a plate. The sexual appetite of the viewer (presumed to be male) is no longer disguised by any erudite pretext; the naked woman is there to be consumed on the spot. Her availability to the consumer is emphasized by the contrasting complete and formal clothing of her less prominent male companions and by her direct eye contact with the audience. The painting

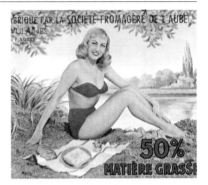

Below: the American Pop artist Tom Wesselmann (born 1931) accentuates artifice by reducing the body of the "perfect woman" to a collection of cartoonlike emblems.

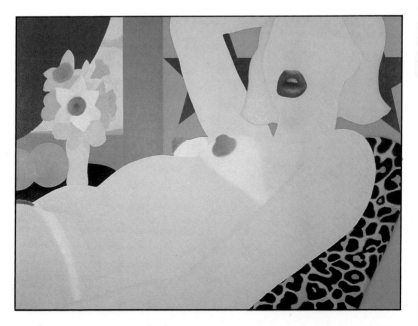

rebukes the puritanism of a bourgeoisie that can deal with the body only when it is "dressed" in a disguise of fables and high culture.

Nude and naked

The nude body has never been depicted as often as in our own time, yet we have never been less naked in our ability to appreciate it. We do not see the body alone; our gaze is conditioned by the thousands of images already stored in our memory that filter our sensations and shape our experience. In fact, we generally consider unclothed bodies "nude" rather than "naked" only in the context of art. Elsewhere, our perception of the body is constructed according to a set of conventional attitudes, largely mediated through fashion, advertising, and film. We use these mass-culture filters to identify what degrees of nakedness are acceptable, what sorts of bodies should or should not be seen, and in what manner and context they may be seen. In consequence, we tend to notice the body's most impersonal aspects, and those which, within the same culture, are the same for everyone. We should admit, perhaps, that even in looking at our own body our individuality is what most easily escapes us.

In the Old Testament, when Ham, son of Noah, looks upon his father naked, he and his descendants are accursed. The prohibition against some kinds of nakedness (of one's parents, of the genitals) is culturally very strong and serves to shroud our origins in mystery. Left: Gustave Courbet's painting, *The Origin of the World,* made only three years after Manet's picnic scene, continues to shock many viewers, where the luncheon on the grass may seem merely puzzling today.

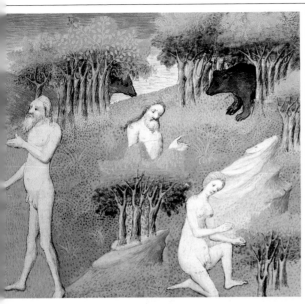

Left: a 15th-century illustration to the Venetian merchant Marco Polo's fanciful tale of his travels and adventures. This scene depicts the fabled Land of the Hermaphrodites, people in whom male and female characteristics are united in one body. In art and myth, the hermaphrodite symbolizes unity by the fusion of opposites.

The experimental artist Marcel Duchamp was always willing to be both provocative and witty, and often dealt in inversions and puns in his work. To interpret the real, he suggested, is to see the opposite of what appears to be. His sculpture *Female Fig Leaf,* 1950 (cast 1961), is a bronze cast of female genitalia.

"O man, modeler or sculptor, can you give yourself the form you choose?" (Giovanni Pico della Mirandola, 1463–94)

Albrecht Dürer once depicted himself as Christ in a self-portrait. Pablo Picasso, in an aggressive mood, boasted of having painted a woman, using her dog as his model. The contemporary artist Bruce Nauman (born 1941) photographed himself spitting, and called the work *Self-Portrait as a Fountain.* We all like to imagine ourselves as shape-changers. Artists especially are inspired, like demiurges, to keep reinventing the human form in new ways, sometimes idealizing and sometimes dramatizing or distorting it. An artist has license to create a body that defies

all the laws of organic structure, anatomy, and genetics. But whether in travesties or idealizations, we rely heavily on the idea of metamorphosis in our self-representations. And this recalls the very function of the image: to analyze and understand the body, to distinguish the possible body from the impossible, and to transform reality. Our love of images—our sense of humor and of play—is both our great achievement and our limitation, the thing that proves us neither god nor monster. We insert imagination and fantasy into the immense machinery of an evolution whose ultimate design eludes us.

This use of metamorphosis and metaphor reveals our frustrated yearning to exercise unlimited power over the body, but it also does something more. Through the image, we give corporeal shape to the insubstantial part of ourselves that we value most, and that otherwise has no physical being. We give a body to our emotions and fears, beliefs and desires. We clothe our soul in flesh.

The body transfigured

We may reasonably speculate that well before the oldest cave paintings, body painting and tattoo were the earliest means of bodily transformation. Painted bodies are not precisely images of the body, but they are also not equivalent to paintings on a wall or other neutral surface. Image and

The body constantly undergoes cultural adaptation. Clothing and hair styles alter its shape; cosmetics transform the face into a living mask. From the frills and panniers of the 18th century to the hourglass corset and bustle of the 19th, fashion forms a close conspiracy between the shaper and the person shaped, but it can be difficult to decide which of the two dominates. Opposite: is the woman or her wig the center of attention in this caricature of 18th-century styles?

Tattooing and body painting mark the first split between the biological body and the symbolic body. Left: an Aboriginal man in Australia wears traditional paint. The overall white decorations transform his body, while the dots and lines on his face subtly emphasize its shape.

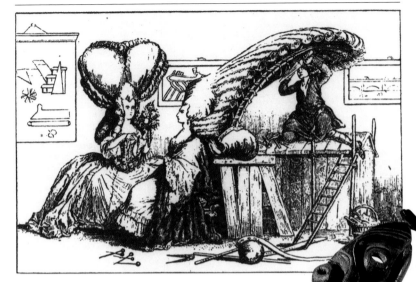

object, glued to one another, are partners. Painting decorates the body, which, in turn, provides the "canvas" on which it appears. Both the painted images and the body that carries them have meanings that affect one another. A painting communicates ideas that no gesture or speech can convey. It may reflect a state of mind for which the body has no expression, or emphasize and interpret the body's language.

The first artist had the truly revolutionary insight that painting could be detached from the body to express ideas and emotions abstractly, on a surface that in itself has no other meaning than to bear the image. This separation of image from object was a decisive improvement in the art of representing ourselves. Removed from the body, the painted image of the body becomes truly representational: the image stands for the object, assuming its full powers in the absence of the thing it represents. The image of the body is the body without the body.

Something similar may perhaps be seen at work in the prime sacrament of Christianity, the Eucharist, or transubstantiation of the Host. In this ceremony, the

Above: a Greenland Eskimo mask.

"A mask is not primarily what it represents, but what it transforms, that is, what it chooses not to represent. Like a myth, a mask denies as much as it affirms."

Claude Lévi-Strauss, *The Way of the Masks,* 1982

"Thou shalt not make unto thee any graven image, or any likeness of any thing that is in heaven above, or that is in the earth beneath, or that is in the water under the earth."

Exodus 20:4

Left: a 16th-century *Icon of the Transfiguration* from Berat, Albania. In the early medieval Christian church, the use of sacred images was condemned by some prelates. In AD 787, the Second Council of Nicaea drew a distinction between an idol, a sacrilegious image worshiped erroneously, and an icon, a sacred image, representing the Incarnation of the word of God. It was not, the Council decreed, idolatrous to venerate icons of Christ, the Virgin, or the saints. Whereas the idol tends to confuse itself with the divinity, the icon is a mediator between human and divine. However, this distinction is not entirely without ambiguity. Thus, some icons dear to popular worship are called *acheiropoetes* (not made by human hand). These images—whether divine or not—mark a form of resurgence of the old idols of antiquity (such as the *xoanon*), worshiped because they "fell from heaven."

bread of the Host miraculously becomes the body of Christ, echoing the words of Jesus, who said of the bread of the ritual meal, at the Last Supper: "This is my body." In Catholic theological terms, the eucharistic statement expresses the sacrifice of the body of Christ by making that body present at the moment of the rite. As a metaphor, it describes a distinctive property of images: their capacity to convey symbolic meanings. Once again, the image stands for the object, assuming its full powers in the apparent absence of the thing it represents.

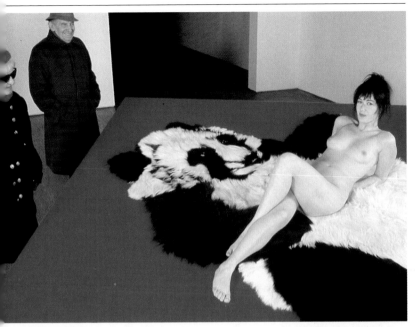

Idol and icon

The image may have only a remote link with the body it represents and in extreme cases may refer to nothing but itself. Such is the case of the idol, the religious image that is worshiped as if it were the deity in person.

Advertising models and film stars are often called idols or icons of the secular world. Their beautiful bodies, honed and polished, enhanced by staging, lighting, and photographic touch-up, exist publicly in immense projected screen images and glossy reproductions printed in vast numbers. As such, they are, essentially, virtual bodies, idealized fetishes that no longer express any tangible reality. The corollary of our admiration for these invented bodies is a devaluation, indeed a negation, of the individual image. Never before have the media so cruelly tantalized ordinary people, confronting us relentlessly with models of illusory perfection, obsessively repeated and wholly inaccessible.

In reaction to the flood of slick perfect-body images

According to the cultural rules of nudity and nakedness, a painting of a nude has the status of a work of art; we are authorized to gaze upon it without embarrassment. Above: Bernard Bazile's 1993 artwork, *Mel Ramos 1*, tests the line between artwork and act of illegal public indecency. Here the painted model is replaced by a flesh-and-blood woman. This "living painting" invites the spectator to react with confusion and ambivalence, and also, perhaps with amusement and pleasure. Real body merges with image of the body.

with which we are inundated commercially, some contemporary artists have returned to the body decoration and tattooing of our distant past. Body painting, scarification, and piercing are the stigmata of an archaic surgery that attempts to inscribe the image once again on the human body, in all its individuality and imperfection.

Modesty: another form of nudity

Between the religious or profane idol, which blocks access to reality, and the performances of some artists who expose their skin and thus attempt to exhaust its secrets, between the hermeneutic image that refers only to itself and the transparent image that wants to exhibit all, there exists a wide panoply of representations that

Below: a 14th-century fresco from the monastery of Christ the Savior in Chora in Istanbul depicts *The Entry of the Elect into Paradise*. On the gate of heaven is the head of a seraph, appearing between two pairs of red wings which form a *mandorla*, a shape that suggests the female genitalia. Far from sacrilegious, this connection is proper, offering a symbolic representation of rebirth in the afterlife and prefigures the resurrection of the flesh.

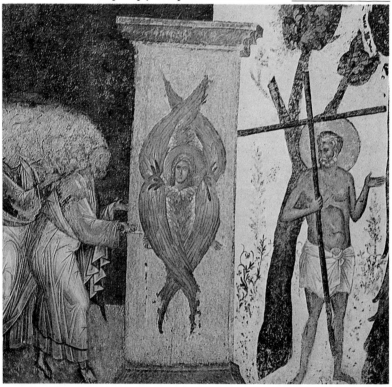

Clothing has three functions: protection, modesty, and adornment. The last is no mere veil or screen, but a surface on which we may present an image of ourselves. Dress both conceals the body and conveys its messages. Left: in Gustav Klimt's 1907–8 painting *The Kiss,* two bodies embrace beneath an overlay of sequins and glittering patterns, but are nonetheless passionate and erotic.

Overleaf: a detail from *The Ascent of the Blessed,* attributed to Hieronymus Bosch, c. 1500.

"I know with certitude that I exist, and…I do not observe that aught necessarily belongs to my nature or essence beyond my being a thinking thing, [so] I rightly conclude that my essence consists only in my being a thinking thing…And although I certainly do possess a body with which I am very closely conjoined; nevertheless, because, on the one hand, I have a clear and distinct idea of myself, [as] only a thinking and unextended thing, and as, on the other hand, I possess a distinct idea of body [as] only an extended and unthinking thing, it is certain that I, [that is, my mind, by which I am what I am], is entirely and truly distinct from my body, and may exist without it."

René Descartes, *Meditationes,* 1641

allow us to apprehend the body, to filter it sufficiently so that we accept its presence. The body appears only by hiding behind what reveals it. Revealing signifies re-veiling.

One of the Greek creation myths tells that Zeus, the god of the heavens who incarnates light, yearned to couple with the somber chthonic goddess of the earth and the underworld, who dwells in blind darkness and whose body is invisible. To seduce her, he wove a robe for her on which he had embroidered the design of the seas and the shape of the continents. Donning this veil, she became visible, so that their union could take place. Sometimes the veil reveals more than it hides. By clothing darkness, it revealed what had before been unbearable to the eye: the unknowable body of the other. Dress gives a recognizable appearance to the mysterious object of desire.

DOCUMENTS

Drawing the body

"The question of the origins of painting is obscure...Some say that its principle was discovered at Sicyon, others claim it was Corinth, but all recognize that it consisted of drawing lines to trace the contour of the human shadow."

Pliny the Elder,
Natural History,
1st century AD

Previous page: a whimsical Renaissance alphabet composed of acrobatic figures. Above: silhouette paintings of human hands are found on the walls of the most ancient prehistoric caves.

Measuring the body

In the 5th century BC, the Greek sculptor Polyclitus created a treatise as well as a statue named the Canon, *establishing the ideal proportions of the human body, upon which many Greek sculptors subsequently based their work. Here, the later Greek writer Galen's description of the* Canon *provides a sense of the treatise's content and the statue's main attributes.*

Beauty, he believes, arises not in the commensurability of the constituent elements [of the body], but in the commensurability [*symmetria*] of the parts, such as that of finger to finger, and of all the fingers to the palm and the wrist, and of these to the forearm, and of the forearm to the upper arm, and, in fact, of everything to everything else, just as it is written in the *Canon* of Polyclitus. For having taught us in that work all the proportions of the body, Polyclitus supported his treatise with a work of art; that is, he made a statue according to the tenets of his treatise, and called the statue, like the work, the "Canon."

Galen (c. AD 129–199),
*On the Principles of Hippocrates
and Plato,* Book V,
2d century AD,
translated by J. J. Pollitt

Modellers and sculptors and painters, and in fact image-makers in general, paint or model beautiful figures by observing an ideal form in each case, that is, whatever form is most beautiful in man or in the horse or in the cow or in the lion, always looking for the mean within each genus. And a certain statue might perhaps also be commended, the one called the "Canon" of

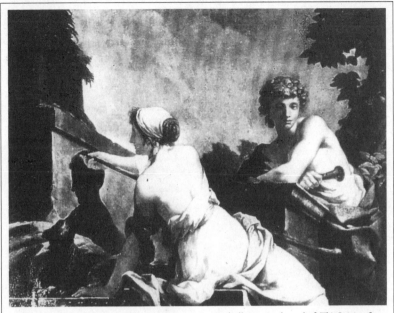

An early 19th-century painting by Jean-Baptiste Regnault illustrates a legend of *The Origin of Drawing* in which a young woman outlines the shadow cast by her beloved.

Polyclitus; it got such a name from having precise commensurability of all the parts to one another.

Galen,
On the Temperaments, Book I,
2d century AD,
translated by J. J. Pollitt

Vitruvius, like Pliny, was a Roman writer who admired the achievements of the Greeks. His treatise on architecture (c. 35–25 BC) reflects the classicizing tastes of his time. Vitruvius's work was a principal source for Renaissance architects seeking to revive the traditions of antiquity. His account of the origin of the Greek architectural orders—Doric, Ionic, and Corinthian—is partly mythical, partly rational conjecture, and explicitly links the proportions of buildings to those of the human form.

When [the Greeks] wished to place columns in [a] temple, not having [the rules of] proportions,…they measured a man's footstep and applied it to his height. Finding that the foot was the sixth part of the height in a man, they applied this proportion to the column. Of whatever thickness they made the base of the shaft they raised it along with the capital to six times as much in height. So the Doric column began to furnish the proportion of a man's body, its strength and grace…

The third order, which is called Corinthian, imitates the slight figure of a maiden; because girls are represented

with slighter dimensions because of their tender age, and admit of more graceful effects in ornament. Now the first invention of [the Corinthian-style] capital is related to have happened thus. A girl, a native of Corinth, already of age to be married, was attacked by a disease and died. After her funeral, the goblets which delighted her when living were put together in a basket by her nurse, carried to the monument, and placed on the top. That they might remain longer, exposed as they were to the weather, she covered the basket with a tile. As it happened the basket was placed upon the root of an acanthus [plant]. Meanwhile about spring time, the root of the acanthus, being pressed down in the middle by the weight, put forth leaves and shoots. The shoots grew up the sides of the basket, and, being pressed down at the angles by the force of the weight of the tile, were compelled to form the curves of volutes at the extreme parts.

Vitruvius,
On Architecture,
Book IV,
on the Doric and Corinthian orders,
1st century BC

The German Renaissance artist Albrecht Dürer differed from many of his contemporaries in not relying on a single, absolute canon of beauty, preferring instead variety and diversity.

Since a man is one whole, made up of many parts, and since each of these parts has its particular nature, equal care must diligently be given to anything whereby they might be marred, so that this might be avoided and that the true, natural character of each part might be most carefully

maintained…First to consider the head…: how strangely is it rounded. And so with other parts: what strange lines they require, such as can be laid down by no rule but must be drawn only from point to point. And so must the forehead, cheeks, nose, eyes, mouth, and chin, with their curvings in and out and their peculiar forms, be carefully drawn…Moreover, just as each several part should be drawn fitly and well, so should it harmonize well in

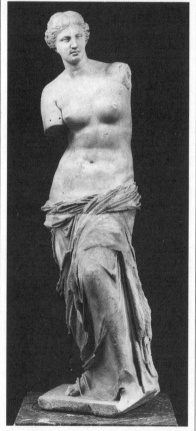

careful finish, and even the tiniest wrinkles and prominences should not be omitted in so far as it is possible... And so in all figures, be they hard or soft, fleshy or thin; one part must not be fat and another bony, as if you were to make fat legs and thin arms...or a figure fat in front and lean behind, and contrariwise...[Each] figure should be of one kind alone throughout, either young, or old, or middle-aged, lean or fat, soft or hard...

Further, in order that we may arrive at a good canon...[it were best] to take measurements from many living men... For one who has understanding may, from men of many different kinds, gather something good together through all the limbs of the body. For seldom is a man found who has all his limbs good, for every man has some fault...

For different kinds of figures different kinds of men are to be copied...One finds amongst the species of men types of every kind, which may be used for figures of diverse sort according to the temperament. So the strong are hard in body like unto lions, whilst the weak are softer and not so rugged as the strong. Therefore it is not seemly to give a soft character to a very strong figure, or to a weak figure a hard character, though as to "thin" and "fat" in figures some allowance must be made...Life in nature shows forth the truth in these things.

Albrecht Dürer,
*Four Books on
Human Proportions*, 1528,
translated by
William Martin Conway

Two Classical Greek views of the female figure: above, a bronze *Veiled Dancer*, probably c. 200 BC, and, left, the marble nude *Aphrodite of Melos (Venus de Milo)*, c. 150–125 BC.

respect of the whole. Thus the neck should agree aright with the head, being neither too short nor too long, too thick nor too thin. Then let a man have a care that he put together correctly breast and the back, the belly, and the hinder parts, the legs, feet, arms, and hands, with all their details, so that the very smallest points be made correctly and in the best way. These things, moreover, should be wrought out in the work to the clearest and most

Assessing the body

*Scientists measure the body;
artists beautify it. We may try to
be objective, but we all consider
the body from within the
context of our own culture.*

The perils of anthropometry

*The biologist Stephen Jay Gould attacks
the idea of biological determinism in* The
Mismeasure of Man. *By looking at the
way racism and cultural attitudes have
shaped perceptions of the human body
throughout history, he refutes the belief
that biology is destiny: that intellectual
inferiority or superiority is determined by
innate biological qualities such as race. In
the following passage, he exposes the false
assumptions underpinning an early 20th-
century study that attempted to prove
biological determinism.*

In 1906, a Virginia physician, Robert
Bennett Bean, published a long,
technical article comparing the brains
of American blacks and whites. With a
kind of neurological green thumb, he
found meaningful differences wherever
he looked—meaningful, that is, in his
favored sense of expressing black
inferiority in hard numbers.

Bean took special pride in his data
on the corpus callosum, a structure
within the brain that contains fibers
connecting the right and left
hemispheres. Following a cardinal
tenet of craniometry, that higher
mental functions reside in the front of
the brain and sensorimotor capacities
toward the rear, Bean reasoned that he
might rank races by the relative sizes of
parts within the corpus callosum. So he
measured the length of the genu, the
front part of the corpus callosum, and
compared it with the length of the
splenium, the back part. He plotted
genu vs. splenium and obtained, for a
respectably large sample, virtually
complete separation between black and
white brains. Whites have a relatively
large genu, hence more brain up front
in the seat of intelligence. All the more

remarkable, Bean exclaimed, because the genu contains fibers both for olfaction and for intelligence! Bean continued: We all know that blacks have a keener sense of smell than whites; hence we might have expected larger genus in blacks if intelligence did not differ substantially between races. Yet black genus are smaller despite their olfactory predominance; hence, blacks must really suffer from a paucity of intelligence…

Throughout this long monograph, one common measure is conspicuous by its absence: Bean says nothing about the size of the brain itself, the favored criterion of classical craniometry. The reason for this neglect lies buried in an addendum: black and white brains did not differ in overall size…

But Franklin P. Mall, Bean's mentor at Johns Hopkins [University], became suspicious: Bean's data were too good. He repeated Bean's work, but with an important difference in procedure—he made sure that he did not know which brains were from blacks and which were from whites until *after* he had measured them. For a sample of 106 brains, using Bean's method of measurement, he found no difference between whites and blacks in the relative sizes of genu and splenium. This sample included 18 brains from Bean's original sample, 10 from whites, 8 from blacks. Bean's measure of the genu was larger than Mall's for 7 whites, but for only a single black. Bean's measure of the splenium was larger than Mall's for 7 of the 8 blacks…

Prior prejudice, not copious numerical documentation, dictates [Bean's] conclusions. We can scarcely doubt that Bean's statement…reflected a prior belief that he set out to objectify, not an induction from data about fronts and backs of brains.

Stephen Jay Gould,
The Mismeasure of Man,
1981

The beauty of hands

In West Africa, the Mende people of Sierra Leone have precise ways of understanding bodily beauty according to an established set of ideals. Since these ideals of beauty are central philosophical tenets, they offer an interesting comparison to classical European tastes. A western anthropologist describes the Mende tradition of appraising the body part by part. Here, women's hands are analyzed.

Mende think that human beings comprise the most interesting category of things in the world…With their imaginations and speech, poses and movements, comings and goings, activities and entanglements, people rivet Mende attention. The development and expression of the human personality and the complexities of human behavior and interaction are an ever-fascinating focus of observation, comment, and speculation.

Within this context of the primacy of the person, women are thought to be by far the most interesting people… The duckling-to-swan change of body lends drama to every female; the internality of her sexuality gives every female mystery…

Hands, *toko*, have a markedly dual nature in Mende thinking. Viewed as a pair, in other words, as a single entity, hands are a sense organ, an external one not situated in the head. As a sense organ, the hands extend out into the

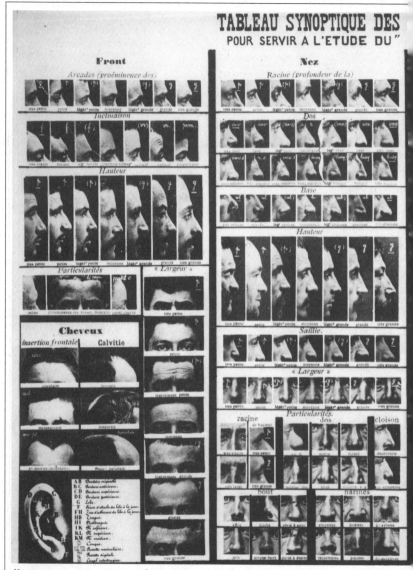

"It is an error to believe that to understand a face it suffices…to stare at it for a long time…To fix its image in your mind it is indispensable that you first make a systematic study of it and that you famil-

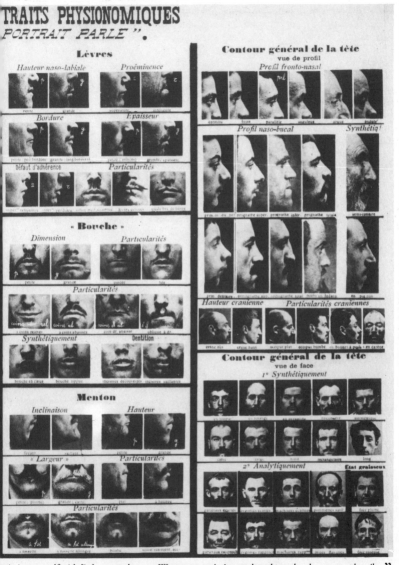

TRAITS PHYSIONOMIQUES
PORTRAIT PARLÉ ".

iarize yourself with [its] nomenclature…We can see again in our thoughts only what we can describe. **"**
Alphonse Bertillon, *La Photographie judiciaire (Forensic Photography),* 1890

world, explore the environment, and through sensations report back on surrounding conditions. Hands also are seen as implements, a set of tools, instruments, an apparatus for performing tasks as ordered by the brain. The beauty of hands is judged by their size, texture, color, and movement. Lovely hands are slim and dainty with long tapering fingers. Fingernails are always cut very short; long nails are "foreign." A woman's hands must be soft and smooth, without the roughness

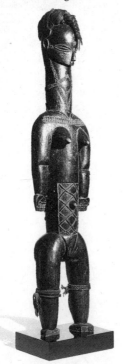

Carved wood figure of a standing woman from Côte d'Ivoire, West Africa, date unknown.

characteristic of hard-working hands. The palm, *tokovělě,* should be light in color even in the darkest person; a black palm is considered a simian attribute, ugly and coarse on a human being. Hands must be flexible in movement; any stiffness is arthritic and disfiguring…

Idiomatically, the hands represent the individual's participation and action, and a number of expressions depend on this association. *Nya toko wili lò hu,* "my hand is in with them," means "I will take part in the activities." *Toko fele kě koi fele,* "two hands and two feet," a statement of agreement, means "I am in it all the way." Hands indicate a person's intentions or interests; so when one says *loko wěě ngi ma*—"rest hand on it," it means accepting it in good faith, accepting completely. The hands are used in settling a dispute or misunderstanding: the touch of the hands, as in a handshake or a pat, is the true sign of forgiveness and reconciliation; without the contact of the hands, forgiveness is not truly given.

Sylvia Ardyn Boone,
Radiance from the Waters,
1986

The unclothed body

In a landmark study, the English art historian Kenneth Clark discusses the difference between "naked" and "nude," and their relation to ideas of beauty in the western art tradition.

The English language, with its elaborate generosity, distinguishes between the naked and the nude. To be naked is to be deprived of our clothes, and the word implies some of the embarrass-

ment most of us feel in that condition. The word "nude," on the other hand, carries, in educated usage, no uncomfortable overtone. The vague image it projects into the mind is not of a huddled and defenseless body, but of a balanced, prosperous, and confident body: the body re-formed. In fact, the word was forced into our vocabulary by critics of the early eighteenth century to persuade the artless [English] that, in countries where painting and sculpture were practiced and valued as they should be, the naked human body was the central subject of art…

It is widely supposed that the naked human body is in itself an object upon which the eye

Study of a Male Nude by Eugène Delacroix (1798–1863).

dwells with pleasure and which we are glad to see depicted. But anyone who has frequented art schools and seen the shapeless, pitiful model that the students are industriously drawing will know this is an illusion. The body is not one of those subjects which can be made into art by direct transcription— like a tiger or a snowy landscape. Often in looking at the natural and animal world we joyfully identify ourselves with what we see and from this happy union create a work of art. This is the process students of aesthetics call

empathy, and it is at the opposite pole of creative activity to the state of mind that has produced the nude. A mass of naked figures does not move us to empathy, but to disillusion and dismay. We do not wish to imitate; we wish to perfect. We become, in the physical sphere, like Diogenes with his lantern looking for an honest man; and, like him, we may never be rewarded. Photographers of the nude are presumably engaged in this search, with every advantage; and having found a model who pleases them, they are free to pose and light her in conformity with their notions of beauty; finally, they can tone down and accentuate by retouching. But in spite of all their taste and skill, the result is hardly ever satisfactory to those whose eyes have grown accustomed to the harmonious simplifications of antiquity.

Kenneth Clark,
The Nude,
1956

The body as metaphor

Poets and philosophers love to use the human body as a metaphor for larger systems. For the political scientist, a well-ordered civil society is likened to a healthy body. For the cleric, a beautiful body is a reflection of God's grace.

A religious metaphor

A subject of great debate in the early Christian church was the key question of whether the soul's resurrection is corporeal or purely spiritual. The theologian St. Augustine interpreted certain biblical statements to mean that at resurrection the human soul regains its body in heaven, in a perfected and complete form. He likened God's resurrection of this perfected human body to the potter's creation of a better vessel or the sculptor's construction of a more beautiful version of a statue.

THE PERFECTION OF THE RESURRECTED BODY

...If we take it that the promise, 'not a hair will perish', means that there will be no deformity in the body, it follows at once that any constituents which would produce deformity if uncontrolled will go to make up the whole bulk of the body, but they will not be in places where they would disfigure the proportions of the parts. There is an analogy in pottery. If clay is used to make a pot, and then the material is brought back to the original lump to make a completely fresh start, it is not essential that the piece of clay which formed the handle should make the handle in the second attempt; and the same with the bottom of the pot, and so on. All that is required is that the whole pot should be re-made out of the whole lump, that is, that all the clay should go back into the whole pot, with nothing left over.

Now the hair has been cut, and the nails have been pared, again and again. And if the restoration of what has been cut would disfigure the body, then it will not be restored. But that does not

mean that anything will 'perish' from the person at the resurrection. Such constituents will be returned to the same body, to take their place in its structure, undergoing a change of substance to make them suitable for the parts in which they are used. And yet, in fact, when the Lord said, 'Not one hair of your head will perish', he can be understood to refer to the number of hairs, not to length of the hair. This more plausible interpretation is supported by the statement elsewhere that 'all the hairs of your head are numbered'. What I mean by saying this is not that I think that anything will perish which is present in any body as belonging to the essential nature of that body; but that anything in that nature that is deformed—and, of course, the sole purpose of the deformity is to give yet another proof of the penal condition of mortals in this life—anything of this kind will be restored in such a way as to remove the deformity while preserving the substance intact. An artist who has for some reason produced an ugly statue can recast it and make it beautiful, removing the ugliness without any loss of the material substance. And if there was any displeasing excess in some parts of the first figure, anything out of proportion to the rest, he does not have to cut it off or throw away any part of the whole; he can simply moisten the whole of the material and remix it, without producing any ugliness or diminishing the quantity of material. If a human artist can do this, what are we to think of the Almighty Artist? Can he not remove all the deformities of the human body, not only the familiar ones but also the rare and the monstrous, such as are in keeping with the miseries of this life, but are utterly incongruous with the future felicity of the saints? Can he not get rid of them, just as the unpleasant products of the waste matter of the body, ugly though natural, are removed without any loss of substance in the body?

This means that fat people and thin people have no need to fear that at the resurrection they will be the kind of people they would not have chosen to be in this life, if they had had the chance. For all physical beauty depends on a harmony between the parts of the body…

A sacred 16th-century Russian icon is not a portrait of an individual man, but a ritual and symbolic representation of Christ as universal man.

Augustine of Hippo (354–430),
City of God, Book XXII,
chapter 19,
c. AD 420–26,
translated by Henry Bettenson

The original engraved frontispiece to Hobbes's *Leviathan* was designed by him. At top is an inscription from chapter 41 of the biblical Book of Job. That chapter begins "Canst thou draw out leviathan with an hook?…Will he make a covenant with thee?" The quoted line, from the end of the chapter, reads: "No power on earth can be compared to him." The image directly beneath it is that of the state seen as a gigantic "artificial man," a prince who wears a crown and holds the sword and crozier of church and state authority. Yet his body is composed of myriad individual people. Has the state swallowed its subjects, or does it exist only as an amalgam of many bodies?

A political metaphor

In political philosophy, the "body politic" is a metaphor for the state, an organic whole composed of many parts: the brain represents the king, who governs, while the members act. Such metaphors may be quite complex, with the nervous system representing the laws, the muscles the army, and so forth. The 17th-century English political philosopher Thomas Hobbes wrote an important analysis of the nature and structure of political systems. The "Leviathan" of his title is this gigantic creature whose health is dependent upon the good order of all its parts.

Nature (the art whereby God hath made and governs the world) is by the art of man, as in many other things, so in this also imitated, that it can make an artificial animal. For seeing life is but a motion of limbs, the beginning whereof is in some principal part within, why may we not say that all automata (engines that move themselves by springs and wheels as doth a watch) have an artificial life? For what is the heart, but a spring; and the nerves, but so many strings; and the joints, but so many wheels, giving motion to the whole body, such as was intended by the Artificer? Art goes yet further, imitating that rational and most excellent work of Nature, man. For by art is created that great LEVIATHAN called a COMMONWEALTH, or STATE (in Latin, CIVITAS), which is but an artificial man, though of greater stature and strength than the natural, for whose protection and defence it was intended; and in which the sovereignty is an artificial soul, as giving life and motion to the whole body; the magistrates and other officers of judicature and execution, artificial joints; reward and punishment (by which fastened to the seat of the sovereignty, every joint and member is moved to perform his duty) are the nerves, that do the same in the body natural; the wealth and riches of all the particular members are the strength; *salus populi* (the people's safety) its business; counsellors, by whom all things needful for it to know are suggested unto it, are the memory; equity and laws, an artificial reason and will; concord, health; sedition, sickness; and civil war, death. Lastly, the pacts and covenants, by which the parts of this body politic were at first made, set together, and united, resemble that fiat, or the Let us make man, pronounced by God in the Creation.

To describe the nature of this artificial man, I will consider

First, the matter thereof, and the artificer; both which is Man.

Secondly, how, and by what covenants it is made; what are the rights and just power or authority of a sovereign; and what it is that preserveth and dissolveth it.

Thirdly, what is a Christian Commonwealth.

Lastly, what is the Kingdom of Darkness...

He that is to govern a whole nation must read in himself not this or that particular man, but mankind...

Thomas Hobbes (1588–1679), Introduction to *Leviathan; or, the Matter, Form, and Power of a Commonwealth, Ecclesiastical and Civil,* 1651

Fantastical anatomies

Anatomical illustrations and skinless écorché waxworks, designed for didactic purposes, inspire both disgust and curiosity. The following passages offer a variety of meditations on these arresting images.

A n illustration by the Surrealist painter René Magritte creates a visual pun.

The poetry of the corpse

The poet Charles Baudelaire (1821–67) explores the strange beauty found in the often-repellent image of death.

SKELETON CREW

1
Colored plates from medical texts
peddled along these dusty quays
where corpses of so many books
rot in endlessly rifled graves,

illustrations which the skill
and rigor of a master hand
have made, however grim the theme,
incontrovertibly beautiful,

often—crowning horror!—display
anatomical mannequins
all vein and muscle, or skeletons
digging, bone on naked bone.

2
Helots of the charnel-house,
submissive and macabre drones,
can all your anguished vertebrae
or those espaliered arteries

reveal what preternatural crop
you wrest from the reluctant earth,
and tell which farmer's granary
your labors are condemned to fill?

Hard emblem of explicit fate,
would you declare by this device
that even in the sepulchre
our promised sleep will be denied?

that Nothingness has played us false,
that even Death is a deceit,
and that throughout eternity
we are intended, after all,

to scrape the unavailing soil

of some forsaken wilderness,
and drive again the heavy spade
under our bare and bleeding foot?

> Charles Baudelaire,
> "Le Squelette laboureur"
> ("Skeleton Crew"),
> from *Les Fleurs du mal*
> *(Flowers of Evil)*, 1857,
> translated by Richard Howard

An artificial cadaver

The novelist Gustave Flaubert (1821–80),
a contemporary of Baudelaire, recounts
the misadventures of two neophytes in
search of medical knowledge and reveals
a fascination with the mysterious insides
of cadavers.

Pécuchet complimented the doctor. "It
must be wonderful to study anatomy?"

M. Vaucorbeil expatiated on the
fascination he had felt for dissections in
earlier days; and Bouvard asked what
relationship there was between the
interior of women and of men.

To satisfy his curiosity, the doctor
extracted a volume of anatomical plates
from his shelf.

"Take it with you! You can look
through them at your leisure at home!"

The skeleton amazed them with the
prominence of its jaw, the holes that
were its eyes, the frightening lengths of
its hands. An explanatory volume was
called for, so they returned to M.
Vaucorbeil. Thanks to the manual by
Alexandre Lauth, they learned the
divisions of the skeleton, expressing
amazement at the spinal column,
sixteen times stronger, it was said, than
if the Creator had made it straight.
"Why sixteen times precisely?"

The metacarpals were upsetting to
Bouvard; and Pécuchet, poring over the

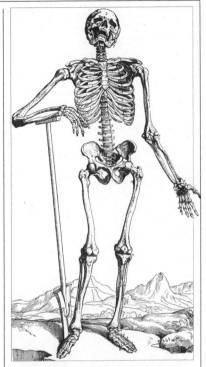

An illustration in Vesalius's 1543 treatise on
anatomy, *De Humani corporis fabrica*
(The Fabric of the Human Body), inspired
Baudelaire's poem.

skull, lost his nerve when faced with the
sphenoid bone, although it looked like
"a Turkish or pseudo-Turkish saddle."

As for the joints, they were buried
under too many ligaments, so they
turned to the muscles.

But the insertions were not easy to
uncover, and, when they reached the
vertebral grooves, they gave up
completely.

At this point Pécuchet said:

"What if we went back to chemistry,
just to be able to use the laboratory?"

Bouvard protested, and seemed to recall reading that artificial cadavers were sometimes manufactured for use in warm countries.

Barberou, to whom he wrote, gave him information on the subject. For ten francs a month, they could have one of the bodies from M. Auzoux, and the following week the delivery man from Falaise deposited an oblong package in front of their gate.

They carried it into the bakehouse, trembling with emotion. When the boards were removed, the straw fell away, the tissue paper slid aside, and the dummy appeared.

It was brick-colored, hairless, without skin, crisscrossed with countless filigrees of blue, red, white. It did not look like a corpse at all, but rather a kind of toy, quite ugly, very clean, smelling of varnish.

Then they removed the thorax and they noticed the two lungs, like two sponges; the heart something like a large egg, a bit tilted toward the rear, the diaphragm, the kidneys, the whole packet of entrails.

"To work!" said Pécuchet.

The day and the evening flew by. They had put on smocks like medical students wear in lecture halls, and while they were working their pieces of cardboard—by the light of three candles—a fist was heard banging on the door. "Open up!"

It was M. Foureau, followed by the field guard.

Little Germaine's teachers had taken pleasure in showing her the model. She had run directly to the grocer's to tell all about it, and the whole village now believed they were concealing a true corpse in their home. Foureau, yielding to the public uproar, was there to determine the facts of the case; gawkers had gathered in the yard.

When they entered, the dummy was lying on its side, and with the facial muscles removed, the eye formed a monstrous bulge, with a frightening effect.

Gustave Flaubert,
Bouvard et Pécuchet, 1880

Dead and alive

In a study of the fantastic and grotesque, Roger Caillois analyzes our peculiar interest in anatomical illustrations.

The illustrations in old books on medicine and surgery…were designed to instruct the doctor, to improve his understanding of the intimate economy of muscles, viscera, and ligaments, and, when the time came, to help the surgical hand guide the scalpel into the irreplaceable flesh. In principle, no images had a greater obligation to be strictly realistic, since in this field

A wooden anatomical model with detachable parts by the Italian anatomist Felice Fontana permitted students to simulate dissections, from the superficial muscles down to the deepest organs. Some of these sculptures have several thousand parts.

inventiveness would be criminal and dangerous. One would say that art has no right to venture here at all, except, with the greatest circumspection, in order to achieve an accurate, meticulous representation of organs that are going to be cut open to the quick. Yet these very images nevertheless invite us to fantasize. With extreme economy of expression, they both conceal and reveal a mystery—discreet, ambiguous, and tenacious. Not all have this capacity: illustrations of trepannings, amputations of limbs, and the setting of fractures do not. In fact, only one kind of picture—during one particular period, in a certain style—seems to open up magical windows on a fantastical universe ruled by unique laws. I refer to those strange depictions of skeletons and écorchés posed, without apparent strain, in banal scenes of ordinary life. We see them expressing a happiness or seriousness that cannot belong to bodies stripped of all sensation and reduced to the impassivity of eternity, or to those subjected to such intolerable tortures that they become pure suffering. Yet [in these engravings] skeletons meditate and écorchés stroll about. They seem determined to ignore a condition that cannot permit them to act as they do—but they deceive no one. Some, denuded almost entirely of their flesh, are reduced to a mere scaffolding; others, who have lost only their outer envelope, should be shrieking [in pain]. Whom do they think they are fooling by affecting to engage in intelligent activity, or by displaying such shocking detachment?

In any case, they are dedicated to demonstrating the inanity of death... [and] we are left to wonder how it is that such illustrations, whose chief virtue is their precision, nevertheless contain more true mystery than the most delirious fantasies of a Hieronymus Bosch. For my part, I return to the notion that this insistent form of the fantastic arises not from some exterior source, but from something intrinsic to the human condition: from a contradiction that bears on the very nature of life, and that appears, momentarily, to succeed in erasing the line separating life from death.

These skeletons shock us because they act as though they were alive. The continue to hear, feel, think, and have emotions. They show avidity and disdain, industry, indifference, and curiosity—especially curiosity about themselves and the secrets of their own bodies, which they are eager both to show to one another and to examine themselves. They present as quite natural a condition that is by definition impossible.

These pseudo-cadavers are disconcertingly dismissive of the role of death, which they in fact also serve to represent. They dissect themselves and one another with patience and care, eager to learn. This vivisection is carried out with the ease and dexterity of real life, in serene landscapes that nonetheless belong to an inconceivable realm. In this new universe, life is resistant, imperishable, shielded from the worst abuses and injuries...But here each body, without suffering the slightest injury or losing the least privilege, is divested at whim of its skin, its flesh, its organs, its blood.

Roger Caillois,
Au coeur du fantastique
(At the Heart of the Fantastic),
1965

Transformations of the body

In health and illness and as we age, our bodies undergo many changes. How often these alterations are a source of anxiety, confusion, and compelling interest may be measured by the frequency with which literature and art address them.

A man of glass

In a moral tale by Miguel de Cervantes, a woman in love with a young man who ignores her doses him with a love potion. This sends him mad, so that he believes his body has turned to glass.

Thomas kept to his bed for six months, becoming so emaciated that he was nothing more, as the saying goes, than skin and bones. All his senses were disrupted, and although he was given every possible remedy, nothing more could be done than to cure his body, but not his mind. He remained sane and yet mad, with the strangest madness anyone had ever seen anywhere. The poor devil imagined that he was made of glass, and when anyone came near, he uttered frightful cries, begging with many words and reasons that no one come too close lest he be broken, swearing that in fact he was not like other men, but was made of glass, from head to toe.

To free him from this singular fantasy, several people, ignoring his cries and pleas, rushed at him and seized him bodily, telling him to take note that he was not breaking. But the only thing they achieved is that the poor man threw himself on the ground with countless cries, then fell into a faint, not to awaken again for four hours. He greeted them with a new round of pleas that he be left in peace. He asked to be spoken to from a distance and told them that they could pose any question they liked. Being a man of glass, not flesh, he would answer more wisely, for glass is a subtle and delicate substance, and the soul is governed by it more readily and effectively than through the intervention of the body, which is composed of a heavy, earthly substance. To determine the truth of what he said,

A 1912 experimental photograph by the Futurist Anton Giulio Bragaglia shows a man in motion.

people asked many difficult questions, to which he responded spontaneously and with remarkable quick-wittedness. The most learned men of the University and the professors of medicine and philosophy greatly marveled to see that a subject of such amazing madness that he believed himself made of glass could also possess enough reason to give such ready and appropriate answers.

Thomas asked to be given some kind of sheath in which he could store this fragile glass of his body, for fear of breaking it if he wore clothing that was too tight... He wanted neither meat nor fish, drank only water from the spring or river, and did so with his hands: and when he went through the streets, he stuck to the middle, keeping an eye on the rooftops and trembling lest some tile fall on him. In summer he slept in the fields under the sky, and in winter he slipped into some poor inn and buried himself in straw up to his neck, saying that this was the safest bed and the one most suited to men made of glass. He would quake at the first sound of thunder, and dash like quicksilver across the countryside, not returning to town until the storm had passed. His friends kept him closed up for a long time; but seeing that his infirmity kept growing worse, they gave in to his pleas and set him free. Thus he was able to go out on the streets, where he evoked amazement and pity in everyone who recognized him...

One day a bee stung him on the neck and he did not dare shake it off for fear of breaking himself; yet he complained. Someone asked how he was able to feel this bee, if his body was glass. He answered that this bee must be some malicious gossip, for gossip is known to have enough power to ruin bodies of bronze, not to mention those of glass.

Miguel de Cervantes (1547–1616), *The Glass Graduate*, 1613

The edible statue

Eating transforms the body, making it grow in mysterious ways. What, exactly, is flesh made of? How is it that flesh has sensation, but substances such as stone do not? In an 18th-century philosophical dialogue, the authors Jean Le Rond d'Alembert and Denis Diderot debate these questions.

D'ALEMBERT: I would appreciate your telling me what distinction you make between the human being and a statue, between marble and flesh.

DIDEROT: Very little. We make marble out of flesh, and flesh out of marble...

D'ALEMBERT: And so the statue has only an inert sensibility; and mankind, animals, perhaps even plants, are endowed with an active sensibility.

DIDEROT: There is, no doubt, such a difference between a block of marble and the tissue of flesh, but you are quite aware that it is not the only one.

D'ALEMBERT: Certainly. Whatever resemblance there may be between the external form of human beings and the statue, there is no relationship between their internal organization. The chisel of the most expert sculptor cannot make even one layer of flesh. But there is a very simple process for converting a dead force into the condition of a live force: it's an experiment that is repeated before our eyes a hundred times a day; yet I have trouble seeing how one can make a body go from inert to active sensibility.

DIDEROT: That's because you do not want to see it. It's a very common phenomenon.

D'ALEMBERT: And what is this very common phenomenon, may I ask?

DIDEROT: I shall tell you, since you don't mind being embarrassed. It happens every time you eat.

D'ALEMBERT: Every time I eat!

DIDEROT: Yes, because in eating, what are you doing? You remove the obstacles in the way of the active sensibility of the food. You assimilate it to yourself; you make it flesh; you animalize it; you make it sensitive; and what you execute upon food is what I shall execute, when I so desire, on marble.

D'ALEMBERT: And how is that?

DIDEROT: How? I shall make it edible.

D'ALEMBERT: Make marble edible? That can't be easy.

DIDEROT: I am about to show you how. I take the statue you see here, I put it in a mortar, and with heavy blows of the pestle—

D'ALEMBERT: Careful, please; that's Falconet's masterpiece. I wouldn't mind if it were a work by Huez or someone else…

DIDEROT: It makes no difference to Falconet; the statue is bought and paid for, and Falconet cares little about present respect and nothing at all about respect in future.

D'ALEMBERT: Well, pulverize away then.

DIDEROT: Once the block of marble is reduced to an impalpable powder, I mix this powder with humus or vegetal earth; I crush them up well together; I water the mixture, and let it putrefy for a year, two years, a century; the time doesn't matter. When the whole thing has been transformed into more-or-less homogeneous matter, into humus, do you know what I do with it?

D'ALEMBERT: I'm sure you don't eat humus.

DIDEROT: No, but there is a means of union, of appropriation, between the humus and me, a *latus* [handle], as a chemist would call it.

D'ALEMBERT: And this *latus* is a plant?

DIDEROT: Very good. In the humus I sow peas, beans, cabbages, other leguminous plants. The plants take nourishment from the soil, and I take nourishment from the plants.

D'ALEMBERT: Whether it's true or not, I like this transition from marble to humus, from humus to the vegetable kingdom, and from the vegetable kingdom to the animal, to flesh.

Denis Diderot,
*Entretien avec d'Alembert
(Conversation with d'Alembert),*
1769

The body and soul merge

The poet Walt Whitman explores the nature of the body in all its variety and detail, in the course of a long, sensual meditation, excerpted here.

I SING THE BODY ELECTRIC

1

I sing the body electric,
The armies of those I love engirth me and I engirth them…

2

The love of the body of man or woman balks account, the body itself balks account,
That of the male is perfect, and that of the female is perfect.

The expression of the face balks account,
But the expression of a well-made man appears not only in his face,
It is in his limbs and joints also, it is curiously in the joints of his hips and wrists,

It is in his walk, the carriage of his
neck, the flex of his waist and knees,
dress does not hide him,
The strong, sweet, supple quality he
has, strikes through the cotton and
broadcloth,
To see him pass conveys as much as the
best poem, perhaps more,
You linger to see his back, and the back
of his neck and shoulder-side.

The sprawl and fulness of babes, the
bosoms and heads of women, the
folds of their dress, their style as we
pass in the street, the contour of their
shape downwards…

7
…Examine these limbs, red, black, or
white, they are so cunning in tendon
and nerve,
They shall be stript that you may see
them.

Exquisite senses, life-lit eyes, pluck,
volition,
Flakes of breast-muscle, pliant
backbone and neck, flesh not flabby,
good-sized arms and legs,
And wonders within there yet.

Within there runs blood,
The same old blood! the same red-
running blood!
There swells and jets a heart, there all
passions, desires, reachings,
aspirations…

9
O my body!…
I believe the likes of you shall stand or
fall with my poems, and that they are
my poems…
Head, neck, hair, ears, drop and
tympan of the ears,

Eyes, eye-fringes, iris of the eye,
eyebrows, and the waking or sleeping
of the lids,…
Cheeks, temples, forehead, chin, throat,
back of the neck, neck-slue,
Strong shoulders, manly beard, scapula,
hind-shoulders, and the ample side-
round of the chest…
All attitudes, all the shapeliness, all the
belongings of my or your body, or of
any one's body, male or female,
The lung-sponges, the stomach-sac, the
bowels sweet and clean,
The brain in its folds inside the skull-
frame,
Sympathies, heart-valves, palate-valves,
sexuality, maternity,
Womanhood, and all that is a woman,
and the man that comes from woman,
The womb, the teats, nipples, breast-
milk, tears, laughter, weeping, love-
looks, love-perturbations and risings,
The voice, articulation, language,
whispering, shouting aloud…
The continual changes of the flex of the
mouth, and around the eyes,
The skin, the sunburnt shade, freckles,
hair,
The curious sympathy one feels when
feeling with the hand the naked meat
of the body,
The circling rivers the breath, the
breathing it in and out,
The beauty of the waist, and thence of
the hips, and thence downward
toward the knees,
The thin red jellies within you or
within me, the bones, and the
marrow in the bones,
The exquisite realization of health;
O I say these are not the parts and poems
of the body only, but of the soul,
O I say now these are the soul!

<div align="right">

Walt Whitman,
from "I Sing the Body Electric," 1881

</div>

The artist's opinion

*The depiction of the body is
subject to many styles and
approaches in art. From the
celebratory representation of
the nude female form in the
academic painting of Alexandre
Cabanel to Marcel Duchamp's
ambiguous and provocative
depiction of one part of a
woman in* Fountain, *these
varying portrayals each reveal
something about our attitudes
toward the flesh we inhabit.*

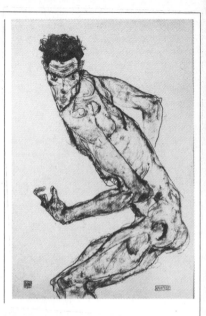

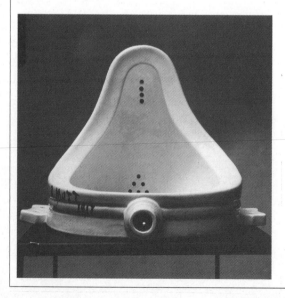

Representations of the body run from the romantic and enticing to the dramatic to the puzzling. Above: Alexandre Cabanel, *The Birth of Venus,* 1863; below: Auguste Rodin, detail from *The Gates of Hell,* 1880–1917; opposite above: Egon Schiele, *Fighter,* 1913; opposite below: Marcel Duchamp, *Fountain,* 1917–64.

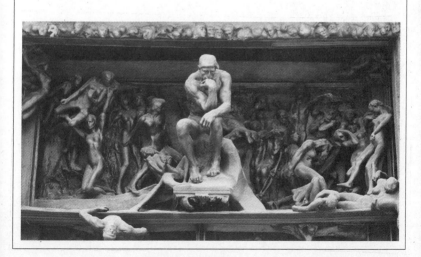

Further Reading

Adler, Kathleen, and Pointon, Marcia, eds., *The Body Imaged: The Human Form and Visual Culture since the Renaissance*, 1993

Barkan, Leonard, *Nature's Work of Art: The Human Body as Image of the World*, 1975

Bataille, Georges, *The Tears of Eros*, trans. P. Connor, 1989

Bynum, Caroline Walker, *The Resurrection of the Body in Western Christianity*, 1995

Caudill, Maureen, *In Our Own Image: Building an Artificial Person*, 1992

Chapuis, Alfred, *Automata*, 1958

Clair, Jean, et al., *Identity and Alterity: Figures of the Body, 1895–1995*, exh. cat., Biennale di Venezia, 1995

Clark, Kenneth, *The Nude: A Study in Ideal Form*, 1972

Damisch, Hubert, *The Judgment of Paris*, trans. J. Goodman, 1996

Descartes, René, *Méditations*, 1641, trans. John Veitch, 1901

Dutton, Kenneth R., *The Perfectible Body: The Western Ideal of Physical Development*, 1995

Feher, Michael, Naddaff, Ramona, and Tazi, Nadia, eds., *Fragments for a History of the Human Body*, 1989

Flynn, Tom, *The Body in Three Dimensions*, 1998

Foucault, Michel, *The Birth of the Clinic: An Archaeology of Medical Perception*, 1972, repr. 1994

Gent, Lucy, and Llewellyn, Nigel, eds., *Renaissance Bodies: The Human Figure in English Culture*, 1990

Hale, Robert Beverly, and Coyle, Terence, *Albinus on Anatomy*, 1979

Heckscher, William S., *Rembrandt's Anatomy of Dr. Nicolaas Tulp: An Iconological Study*, 1958

Hillman, David, and Mazzio, Carla, eds., *The Body in Parts: Fantasies of Corporeality in Early Modern Europe*, 1997

Hunt, Lynn, ed., *Eroticism and the Body Politic*, 1990

Kurzweil, Raymond, *The Age of Intelligent Machines*, 1990

Lucie-Smith, Edward, *Sexuality in Western Art*, 1991

Nochlin, Linda, *The Body in Pieces: The Fragment as a Metaphor of Modernity*, 1994

Panofsky, Erwin, *Meaning in the Visual Arts*, 1970

Perrot, Philippe, *Fashioning the Bourgeoisie: A History of Clothing in the Nineteenth Century*, trans. R. Bienvenu, 1994

Popham, A. E., *The Drawings of Leonardo da Vinci*, 1946, repr. 1973

Pultz, John, *The Body and the Lens: Photography 1839 to the Present*, 1995

Roberts, K. B., *The Fabric of the Body: European Traditions of Anatomical Illustrations*, 1992

Sawday, Jonathan, *The Body Emblazoned: Dissection and the Human Body in Renaissance Culture*, 1995

Sennett, Richard, *Flesh and Stone: The Body and Civilisation in Western Culture*, 1994

Shilling, Chris, *The Body and Social Theory*, 1993

Stafford, Barbara Maria, *Body Criticism: Imaging the Unseen in Enlightenment Art and Medicine*, 1991

Suleiman, Susan Rubin, ed., *The Female Body in Western Culture: Contemporary Perspectives*, 1985

Tomlinson, J. D. W., and Roberts, K. B., *The Fabric of the Body: European Traditions of Anatomical Illustration*, 1992

List of Illustrations

Key: *a*=above, *b*=below, *l*=left, *r*=right, *c*=center

Front cover, clockwise from top: Aphrodite of Cyrene, Greek, marble, 2d century BC, Museo delle Terme, Rome; Leonardo da Vinci, drawing, ink on paper, Royal Library, Windsor; Etienne-Jules Marey, detail of a chrono-photograph, c. 1890, Musée Marey, Beaune; Andreas Vesalius, two engravings from *De*

Humani corporis fabrica, Basel, 1543; photograph, c. 1936; Leonardo da Vinci, *Vitruvian Man*, drawing, 1490, Galleria dell'Accademia, Venice; X-ray of a head, profile view **Spine:** Detail of an anatomical illustration in Guy de Pavia, *Liber notabilium Philippi Septimi*, 1345, Musée Condé, Chantilly **Back cover:** Anatomical illustration, illuminated manuscript, 1292,

Bodleian Library, Oxford *1* Jacques-Fabien Gautier d'Agoty, color engraving in *Exposition anatomique du corps humain*, 1759, Ecole Nationale Supérieure des Beaux-Arts, Paris

1 (inset) MRI (magnetic resonance image) scan of the brain, axial section *2* Gautier d'Agoty and Jacques-François Duverney, color engraving, plate I of *Myologie complette en couleur et grandeur*

naturelle, 1746, Ecole Nationale Supérieure des Beaux-Arts, Paris *3* MRI brain scan *4* Gautier d'Agoty and Duverney, color engraving in *Myologie complette*, 1746, Ecole Nationale Supérieure des Beaux-Arts, Paris *5* X-ray of the shoulder *6* Gautier d'Agoty and Duverney, color engraving, plate X of *Myologie complette*, 1746, Ecole Nationale Supéri-

eure des Beaux-Arts, Paris
7 MRI scan of the torso
8 Gautier d'Agoty and Duverney, color engraving in *Myologie complette,* 1746, Ecole Nationale Supérieure des Beaux-Arts, Paris
9 MRI scan of the feet
11 Andrea Mantegna, *The Dead Christ,* tempera on canvas, c. 1500?, Pinacoteca di Brera, Milan
12 Aphrodite of Cyrene, Greek, marble, 2d century BC, Museo delle Terme, Rome
13 Francesco di Giorgio (1439–1502), detail of a drawing from the *Trattato di architettura civile e militare,* Biblioteca Nazionale, Florence
14l Hera of Samos, Greek, marble, c. 570–560 BC, Musée du Louvre, Paris
14r Female statuette from the Delphineum of Dreros-Apollo, Greek, bronze over wood core, c. 700 BC, Archaeological Museum, Heraklion, Crete
15 Luca Cambiaso, *Man and Child,* ink on paper, c. 1550, Graphische Sammlung Albertina, Vienna
16 Venus of Laussel, cast of a palaeolithic stone figurine, Musée d'Aquitaine, Bordeaux
17l, 17r Two stylized female figurines, casts of palaeolithic objects from Moravia, Musée de l'Homme, Paris
18a Artist's sketch of the pharaoh Thutmose III, with transfer grid, Egyptian, from Thebes, New Kingdom (18th Dynasty), British Museum, London
18b Scene of Agricultural Labors, wall painting, Egyptian, from Thebes, New Kingdom (18th Dynasty, c. 1450 BC), Musée du Louvre, Paris

19 Unfinished sculptor's model of the god Osiris, Egyptian, Late Period, Musée du Louvre, Paris
20 Display of the Deceased, painted detail of a geometric-style vase, Greek, 8th century BC, Musée du Louvre, Paris
21l Lady of Auxerre, Greek, limestone, c. 640 BC, Musée du Louvre, Paris
21r After Praxiteles, *Aphrodite of Cnidus,* Roman copy of a Greek original, marble, c. 350 BC (original), Museo Pio-Clementino, Vatican City
22l Kouros of Volomandra, Greek, marble, 6th century BC, National Archaeological Museum, Athens
22r After Polyclitus, *Doryphorus,* Roman copy of a Greek original, marble, c. 440 BC, Museo Archeologico Nazionale, Naples
23 Jean-Marc Reiser, "Pour une guerre plus humaine," illustration in *Hara-Kiri,* 1 December 1969
24 Francesco di Giorgio Martini (1439–1502), *Plan for an Ideal City,* detail of a drawing, 15th century, Biblioteca Reale, Turin
25 Giorgio De Chirico, *Hector and Andromache,* oil on canvas, 1917, private collection, Milan
26 Lucas Cranach the Elder, *The Judgment of Paris,* oil on panel, 1530, Kunstmuseum, Basel
27 Michelangelo, *Reclining Figure,* terracotta, c. 1526, Casa Buonarroti, Florence
28l Leonardo da Vinci, *Vitruvian Man,* drawing, 1490, Galleria dell'Accademia, Venice
28r Albrecht Dürer, drawing from the *Dresden Sketchbook,* 1510
29 Jacopo de' Barbari, *Portrait of Fra Luca*

Pacioli, oil on canvas, c. 1495, Museo Nazionale di Capodimonte, Naples
30a Oskar Schlemmer, drawing from *Homme et figure artistique,* 1926
30b–31b Yves Klein, *Anthropometry (No. 82),* pigment on paper, Musée National d'Art Moderne, Paris
31a Le Corbusier, *Modulor,* illustration in *Poème de l'angle droit,* Paris, 1955
32 Paul Richer, photographs and notes from an anthropometric report, c. 1915, Département de Morphologie, Ecole Nationale Supérieure des Beaux-Arts, Paris
33a Paul Broca, illustration of the double-square procedure for measurement, 1865
33b Average Man, illustration in *The Measure of Man,* Whitney Publications, 1959
34 A. Thooris, *The Four Fundamental Morphological Types,* illustration in *La Vie par le stade,* Paris, 1924
35a A. Thooris, *Cubic Muscular Type,* illustration in *La Vie par le stade,* Paris, 1924
35b Ideal Man, illustration in Eugen Matthias, *Der Männliche Körper,* Zurich and Leipzig, 1931
36l Photograph, c. 1936
36r–37 The Goddess Nut, mural from the tomb of Ramesses VI, Egyptian, 20th Dynasty, Valley of the Kings
38 Masaccio, *Adam and Eve,* detail of a fresco, 1427–28, Brancacci Chapel, Church of the Carmine, Florence
39 Trez, untitled drawing
40l René Magritte, *The Eternally Obvious,* oil on canvas, five units, 1930, Menil Foundation, Houston

40r–41l Alberto Giacometti, *The Couple,* bronze, 1926, Sylvia and Joseph Slifka Collection, New York
41 H. Hazler, drawing of a Dogon bas-relief, 1923
42a Sheela-na-gig, stone corbel sculpture, c. 1120–40, Church of Saint Mary and Saint David, Kilpeck, Herefordshire
42–43 Giant of Cerne Abbas, incised earthwork, c. 1st century BC?, Dorchester, Dorset
43 Priapic figure, Greek, terracotta, 2d century AD, Museum of Ephesus, Turkey
44 Paul Cézanne, *The Rape,* oil on canvas, 1867, collection of the Provost and Fellows of King's College, Cambridge
45 Painted hydra, Greek, 6th century BC, Kunsthistorisches Museum, Vienna
46 Peter Paul Rubens, *The Victor's Triumph,* oil on canvas, 1614, Staatliche Kunstsammlungen, Kassel
47a Jacob Jordaens, *The Daughters of Kecrops,* oil on canvas, 1617, Musée des Beaux-Arts, Antwerp
47b Camembert cheese label
48 Carlo Urbino, after Leonardo da Vinci, drawing, c. 1550, Pierpont Morgan Library, New York
49a Master of Flora, *Birth of Cupid,* oil on panel, c. 1550, Metropolitan Museum of Art, New York
49b Tintoretto, *Male nude,* pencil on paper (detail), c. 1570, Galleria degli Uffizi, Florence
50 Albrecht Dürer, engraving from *Four Books on Human Proportions,* Nuremberg, 1528
51 Duane Hanson, *Housewife,* synthetic resin with oil and found objects, 1970, private collection, Berlin
52 Charles Le Brun, *Stud-*

ies of the Expression of the Passions, ink on paper, 1668, Musée du Louvre, Paris

53a Guillaume Duchenne de Boulogne, "Provoking an Expression of Terror through Administration of Electricity to the Face," photograph from *Mécanisme de la physionomie humaine,* Paris, 1862

53b Franz Xaver Messerschmidt, *The Yawner,* stone, c. 1760–63, Österreichische Galerie, Vienna

54 Gavarni, *Balzac,* caricature, ink on paper, 1854, Bibliothèque Nationale, Paris

55a Grandville, *Man Descends toward the Brute,* drawing, 1843

55b Grandville, *Apollo Descends toward the Frog,* drawing, 1844

56a *Statuette with facialized belly,* terracotta, 6th century BC, Antikenmuseum, Berlin

56b Esther (age 3), drawings of human beings, 1988

57 Ernst Mach, *Self-Portrait of the Ego,* illustration in *Essai d'analyse des sensations,* 1900

58 Wax ex-votos in the Church of San Alfio, Trecastagni, Sicily

59 Willem de Kooning, *Woman I,* oil on canvas, 1952, Museum of Modern Art, New York

60–61 Jean-Paul Goude, *The French Correction,* montage of drawings and photographs, 1972

62a Wilder Penfield, *Sensory Homunculus,* a "brain map," 1948

62b–63b *Heavenly Body,* painting on an American B-29 bomber plane, 1945

63a Francis Bacon, *Three Studies of the Male Back* (left panel of a triptych), oil on canvas, 1970, Kunsthaus, Zurich

64 Henri Dittmers,

engraving, frontispiece to Thomas Bartholin, *Anatomia reformata,* 1651

65 Detail of an ancient Roman mosaic with the inscription, in Greek, KNOW THYSELF, Museo delle Terme, Rome

66 Detail of an anatomical illustration in Guy de Pavia, *Liber notabilium Philippi Septimi,* 1345, Musée Condé, Chantilly

67a Illustration in a 16th-century edition of Ibn Sina (Avicenna), *Canon of Medicine,* Bibliothèque Nationale, Paris

67b Anatomical illustration, illuminated manuscript, 1292, Bodleian Library, Oxford

68 Johannes de Ketham, *Anatomy Lesson,* color print in *Fasciculus medicinae,* Venice, 1491, Musei Civici, Padua

69 Sagittal section of the body, after John Arderne, *De Arte phisicali et chirurgia,* c. 1412, MS. X.118, Kungliga Biblioteket (Royal Library), Stockholm

70 Attributed to Michelangelo, *Dissection Scene,* ink on paper, 16th century

70–71l Ligier Richier, stone sculpture from the tomb of René de Châlons, after 1544, Church of St.-Etienne, Bar-le-Duc

71r Anonymous color engraving, after Perino del Vaga, from Charles Estienne, *De Dissectione,* 1545, Bibliothèque Nationale, Paris

72 Leonardo da Vinci, drawings, ink on paper, Royal Library, Windsor

73 Leonardo da Vinci, *Successive Cross-Sections of the Lower Leg,* ink on paper, Royal Library, Windsor

74 Andreas Vesalius, engraving from *De Humani corporis fabrica,* Basel, 1543

75a Vesalius, engraving

from *De Humani corporis fabrica,* Basel, 1543

75b Vesalius, engraving from *De Humani corporis fabrica,* Basel, 1543

76l Joannes de Ketham, plate in *Fasciculus medicinae,* Venice, 1491, Musei Civici, Padua

76r–77l Andrea Mantegna, *Saint Sebastian,* tempera on canvas, 1490, Ca' d'Oro, Venice

77r Marksmanship target

78a Bernard Siegfried Albinus, *The Fourth Order of Muscles, Front View,* in *Tabulae sceleti et musculorum corporis humani,* Leyden, 1747

78b Ludovico Cigoli, *La Bella Notomia,* bronze, c. 1600, Museo Nazionale del Bargello, Florence

79 Rembrandt, *The Anatomy Lesson of Dr. Joan Deyman,* oil on canvas, 1656, Rijksmuseum, Amsterdam

80a–81l Paolo Mascagni, *Anatomiae universae icones,* published 1823–31, plate engraved and colored 1823 by Antonio Serantoni, Bibliothèque Nationale, Paris

80b Philippe Comar, morphological study, pastel on black panel, 1992, Ecole Nationale Supérieure des Beaux-Arts, Paris

81 Gautier d'Agoty and Duverney, color engraving in *Myologie complette,* 1746, Ecole Nationale Supérieure des Beaux-Arts, Paris

82 André-Pierre Pinson, head, neck, and torso muscles, wax figure, c. 1780, Comparative Anatomy Laboratory, Muséum d'Histoire Naturelle, Paris

83a, 84a, Francesco Calenzuoli, lymphatic ganglia and facial and neck veins, wax figure, c. 1820, Muséum

d'Histoire Naturelle, Paris

83b Francesco Calenzuoli, view of the head with nerves exposed, wax figure, c. 1820, Muséum d'Histoire Naturelle, Paris

84b Francesco Calenzuoli, muscles of the face and neck, wax figure, c. 1820, Muséum d'Histoire Naturelle, Paris

85 André-Pierre Pinson, head of a woman with dismountable parts, wax figure, c. 1780, Comparative Anatomy Laboratory, Muséum d'Histoire Naturelle, Paris

86al James Montgomery Flagg, *I Want You for the U.S. Army,* poster, 1915

86ar Anonymous, *I Want You for the U.S. Army,* poster, 1917

86b Franz Tschackert with his *Man of Glass,* photograph, 1930, collection of Dr. Martin Roth, Berlin

87 Dr. Menard examines a thoracic X-ray, Cochin Hospital, Paris, 1914

88a, 88b MRI scans of the head

89 Full-body scintigraphic bone scan

90a Mammary thermographic scan

90b X-ray of a head

91 H. Takasaki, *Projection of Shimmering Grill Design on a Back,* photograph

92 Marcel Duchamp, *Nude Descending a Staircase,* oil on canvas, 1912, Philadelphia Museum of Art, Louise and Walter Arensberg Collection

93 Attilio Mussino, illustration for a 1935 edition of *Pinocchio,* by Carlo Collodi

94 Bell idol, painted terracotta, c. 700 BC, Boeotia, Greece, Musée du Louvre, Paris

95l Jointed doll, terracotta, 4th century BC,

Greece, Musée du Louvre, Paris

95r Jointed baker, wood, Middle Kingdom, Egypt, Musée du Louvre, Paris

96 Anonymous modern diagram after Hero of Alexandria, *Treatise on Automata*, 2d century BC

97 Bell jack, cathedral of Dijon

98a Giovanni Alphonso Borelli, illustrations from *De Motu animalium*, 1680

98b Carlo Urbino, after Leonardo da Vinci, *Study of Human Statics*, drawing, c. 1570, Pierpont Morgan Library, New York

99 Rembrandt, *Beheading of John the Baptist*, ink on paper, Musée du Louvre, Paris

100 Pierre Jacquet-Droz, Little Writer automaton, 1774, Musée d'Art et d'Histoire, Neuchâtel, Switzerland

101 Poyet, illustration of a device to synthesize vowels, from *La Nature*, 1908

102–3l Etienne-Jules Marey, chronophotograph, c. 1890, Musée Marey, Beaune

103r The photographer's model Demeny in costume for a chronophotograph, 1883, Musée Marey, Beaune

104–5 Etienne-Jules Marey, *Leap over an Obstacle*, chronophotograph, 1884

106a, 106c Frank B. Gilbreth, graphic-record photographs, from *Applied Motion Study*, 1919

106b–7l Paul Richer, *Synthesis of Running*, phenakistiscope, c. 1900, Morphology Department, Ecole Nationale Supérieure des Beaux-Arts, Paris

107r Etienne-Jules Marey, *Runner Wearing Various Sensors*, illustration from *Animal Mechanism*, 1873

108 Umberto Boccioni,

Unique Forms of Continuity in Space, bronze, 1913, Museum of Modern Art, New York. Acquired through the Lillie P. Bliss Bequest

109 Fritz Lang, still from the film *Metropolis*, 1926

110 Titian, *Intertwined Couple*, crayon on paper, c. 1560, Fitzwilliam Museum, Cambridge

111 Christophe, *The Fenouillard Family on Vacation*, comic strip, 1893

112l Female statuette, 11th Dynasty, Egyptian, from Asyut, painted wood, Musée du Louvre, Paris

112r–13 Enrico Job, detail of *Il Mappacorpo*, photocollage, 1974, collection of the artist

114 Caravaggio, *Head of Medusa*, oil on canvas, 1596–97, Galleria degli Uffizi, Florence

115 After Philippe de Champaigne, *The Veil of Veronica*, 17th century, Musée des Beaux-Arts, Caen

116 Pierre Bonnard, *Nude in the Bathtub*, oil on canvas, 1935, Musée d'Art Moderne de la Ville de Paris

117a NEW: Collection Top Hard Core, advertisement for a French pornographic video, c. 1993

117b Reiser, illustration in *The Oboulot Family on Vacation*, Paris, 1989

118 Edouard Manet, *Le Déjeuner sur l'herbe*, oil on canvas, 1863, Musée d'Orsay, Paris

119a Cheese label, private collection

119b Tom Wesselmann, *Great American Nude (No. 57)*, collage, 1964, Whitney Museum of American Art, New York

120b Gustave Courbet, *The Origin of the World*, oil on canvas, 1866, private collection

120a–21a In the Land of the Hermaphrodites, illumination from an edition of Marco Polo, *Livre des Merveilles*, 15th century, Bibliothèque Nationale, Paris

121b Marcel Duchamp, *Female Fig Leaf*, bronze, 1950, cast 1961, Philadelphia Museum of Art, Gift of Mme Duchamp

122 Aboriginal man wearing ceremonial white paint, Australia, c. 1993

123a Caricature, 1891, mimicking the style of illustrations c. 1755

123b Eskimo mask, wood, from Greenland, Musée de l'Homme, Paris

124 Icon of the Transfiguration, panel painting, 16th century, Berat, Albania

125 Bernard Bazile, *Mel Ramos I*, installation with performance, May 1993, Musée National d'Art Moderne, Centre Georges Pompidou, Paris

126 Detail of *The Entry of the Elect into Paradise*, fresco, 14th century, monastery of Christ the Savior in Chora, Istanbul

127 Gustav Klimt, *The Kiss*, oil on canvas, 1907–8, Österreichische Galerie, Vienna

128 Attributed to Hieronymus Bosch, *The Ascent of the Blessed*, oil on panel, c. 1500, Ducal Palace, Venice

129 Giovanni Battista Bracelli, *Figurative Alphabet*, 1632

130 Palaeolithic silhouette drawing of a hand, cave of Pech-Merle, France

131 Jean-Baptiste Regnault (1754–1829), *The Origin of Drawing*, oil on canvas, early 19th century, Versailles

132 Aphrodite of Melos (*Venus de Milo*), Greek, 2d century BC, marble,

Musée du Louvre, Paris

133 Veiled Dancer, Greek, c. 200 BC?, bronze, Metropolitan Museum of Art, New York

136–37 Alphonse Bertillon, synoptic table of human facial features, from *La Photographie judiciaire*, 1890, Jean Henri collection

138 Figure of a woman, wood, Côte d'Ivoire, undated, private collection

139 Eugène Delacroix, *Study of a Male Nude*, oil on canvas, 19th century, Musée du Louvre, Paris

141 Icon, panel painting, 16th century, Russia

142 Engraved frontispiece to the 1st edition of Thomas Hobbes's *Leviathan*, London, 1651, University of Virginia Library, Special Collections

144 René Magritte, illustration from André Breton, *Qu'est-ce que le surréalisme?*, based on the 1934 painting *The Rape*

145 Andreas Vesalius, engraving from *De Humani corporis fabrica*, Basel, 1543

146 Felice Fontana, wooden model with removable parts, Musée de l'Ancienne Faculté de Médecine, Paris

148 Anton Giulio Bragaglia, *Cercando*, photograph, 1912

152a Egon Schiele, *Fighter*, gouache and pencil on paper, 1913 (Kallir D.1438), private collection

152b Marcel Duchamp, *Fountain*, readymade, 1917, reworked 1964, location unknown

153a Alexandre Cabanel, *The Birth of Venus*, oil on canvas, 1863, Musée d'Orsay, Paris

153b Auguste Rodin, detail of *The Gates of Hell*, bronze, 1880–1917, Musée Rodin, Paris

Index

Page numbers in *italics* refer to captions or illustrations.

A, B, C

Alberti, Leon Battista, 27–28, 50
Albinus, Bernard Siegfried, *78*
Anthropometry, 33–34
Aphrodite, 117, *see also* Venus
Aphrodite of Cyrene, *12*
Aphrodite of Melos, 34, *132*
Apollo, 40, 43, *55*
Arderne, John, *69*
Aristophanes, 39
Aristotle, 67
Artemis, *14*
Augustine of Hippo, 140–141
Avicenna, *67*
Bacon, Francis, *63*
Balzac, Honoré de, *54*, 99
Bartholin, Thomas, *64*
Bataille, Georges, 59
Baubo, *56*
Baudelaire, Charles, 36, 117, 144–145
Bazile, Bernard, *125*
Benveniste, Emile, 20
Bernini, Gianlorenzo, 99
Bertillon, Alphonse, 33, *136–137*
Bertillon, Jacques, 33
Bichat, Xavier, 80–81, 87
Birth of Cupid, *49*
Boccioni, Umberto, *108–109*
Bonnard, Pierre, *116*
Boone, Sylvia Ardyn, 135–138
Borelli, Giovanni Alfonso, *98*
Bosch, Hieronymus, *128*
Bragaglia, Anton Giulio, *148*
Broca, Paul, *33*
Cabanel, Alexandre, 119, *153*
Caillois, Roger, 146–147
Calenzuoli, Francesco, *83*, *84*
Cambiaso, Luca, *15*
Canon, see Polyclitus
Caravaggio, *114*

Cerne Abbas, giant of, *42–43*
Cervantes, Miguel de, 148–149
Cézanne, Paul, *44*, 90
Christ, *115*, 123–124, *141*
Chronophotograph, 103–107
Cigoli, Ludovico, *78*
Cioran, E. M., 116
Clark, Kenneth, 138–139
Classical art, 41–43, 46, 47, 48
Columns, *13*, 15, 131–132
Courbet, Gustave, *120*
Cranach, Lucas, *26*

D, E, F

Daedalus, 94–95
D'Agoty, Jacques-Fabien Gautier, *81*
Darwin, Charles, 53
De' Barbari, Jacopo, *29*
De Chirico, Giorgio, *25*
De Kooning, Willem, *59*
Delacroix, Eugène, 48, 102, *139*
Descartes, René, 97–100, 107–108, 127
Diderot, Denis, 99, 149–150
Diodorus of Sicily, 40
Dionysus, 56
Dogon sculpture, 40, *41*
Duchamp, Marcel, 45, 87, *92*, 121, *152*
Duchenne de Boulogne, Guillaume, *53*
Dürer, Albrecht, *28*, 29, *50*, 121, 132–133
Dyck, Anthony Van, 47
Eakins, Thomas, 102
Écorché, *74*, 74–79, *78*
Entry of the Elect into Paradise, The, *126*
Erasistratus, 66
Estienne, Charles, *71*
Eugenics, 35
Euripides, 111
Eve, *38*
Ex-votos, *58*
Fertility images, *16–17*, *42–43*
Flaubert, Gustave, 145–146
Fontana, Felice, *146*

Freud, Sigmund, 118
Futurists, 108–109

G, H, I

Galen of Pergamum, 23, 67, 130–131
Galton, Francis, 35
Gavarni, *54*
Giacometti, Alberto, 31, *40–41*
Gilbreths, *106*, 107
Goethe, Johann Wolfgang von, 117
Goude, Jean-Paul, *60–61*
Gould, Steven Jay, 134–135
Gracq, Julien, 87
Grandville, Jean-Ignace-Isidore Gérard, *55*
Haeckel, Ernst, 57
Hanson, Duane, *51*
Hera, *14*
Hercules, 47
Hermaphrodites, *120–121*
Hermes, temple of, *13*
Herodotus, 94
Hero of Alexandria, *96*
Herophilus, 66
Hippocrates, 66
Hobbes, Thomas, *142*
Horace, 43
Hounsfield, Godfrey, 88
Husserl, Edmund, 25
Icon of the Transfiguration, *124*
Ingres, Jean-Auguste-Dominique, 15

J, K, L

Jacquet-Droz, Henri and Pierre, *100*, 101
Job, Enrico, *112–113*
Jones, Grace, *60–61*
Jordaens, Jacob, 47
Ketham, Johannes de, *68*, 76
Klein, Yves, *30–31*
Kleist, Heinrich von, 109
Klimt, Gustav, 127
Lady of Auxerre, *21*
La Mettrie, Julien de, 100
Lang, Fritz, *109*
Lavater, Johann Kaspar, 53–54, 55
Le Brun, Charles, *52*, 53
Le Corbusier, *31*, 36
Lévi-Strauss, Claude, 123

Lombroso, Cesare, 54

M, N, O

Mach, Ernst, 57
Magnetic resonance imaging, 88, 91
Magritte, René, 40, *144*
Manet, Edouard, *118*, 119–120
Mantegna, Andrea, 76–77
Manzolini, Anna Morandi, 83
Manzolini, Giovanni, 83
Marey, Etienne-Jules, *102–103*, 103–107, *104–105*, 107
Martini, Francesco di Georgio, 24
Masaccio, *38*
Mascagni, Paolo, 80–81
Medusa, 113, 114–116
Messerschmidt, Franz Xaver, 53
Michelangelo, 27, 35–36
Mondrian, Piet, 62
Montesquieu, Charles de, 37
Muybridge, Eadweard James, 102, 103, 106
Nauman, Bruce, 121
Nicholas of Cusa, 37
Nut, *37*
Osiris, 113–114, 115

P, Q, R

Pacioli, Fra Luca, 29–30
Pavia, Guy de, *66*
Penfield, Wilder, 62
Perino del Vaga, *71*
Phenakistiscope, *106–107*
Picasso, Pablo, 121
Pico della Mirandola, Giovanni, 121
Piero della Francesca, 29
Pinocchio, *93*
Pinson, André-Pierre, *82*, *85*
Plato, 39, 40, 56, 117
Pliny the Elder, 130
Plutarch, 45–46
Pollack, Jackson, 62
Pollaiuolo, Antonio, 70–71
Polyclitus, 21, *22*, 23, 130, 131
Poussin, Nicolas, 13

Praxiteles, *21*
Prehistoric art, *16–17, 130*
Priapus, *43, 43–44*
Protagoras, 23
Proust, Marcel, 88
Pygmalion, 116–117
Quételet, Adolphe, 32
Regnault, Jean-Baptiste, *131*
Reinach, Salomon, 34
Rembrandt, *79, 99*
Renoir, Pierre-Auguste, 36
Richer, Paul, *32, 34*
Richier, Ligier, *70*
Rilke, Rainer Maria, 39

Rodin, Auguste, 59, 93, *153*
Röntgen, Wilhelm, 86
Rousseau, Jean-Jacques, 116
Rubens, Peter Paul, *46*, 47, 48

S, T, U

Schiele, Egon, 36, *152*
Schlemmer, Oskar, *30*
Scintigraphic scan, *89, 91*
Shakespeare, William, 53
Sheela-na-Gig, *42*
Sina, Ibn, *67*
Spinoza, Baruch, 89

Susini, Clemente, 83
Thermographic image, *90*
Thooris, A., *34*
Tintoretto, *49*
Titian, *110*
Tschackert, Franz, *86*
Uncle Sam, *86*
Urbino, Carlo, *98*

V, W, X, Y, Z

Valéry, Paul, 13, 91
Vasari, Giorgio, 70–71
Vaucanson, Jacques de, 100–101
Veiled Dancer, 133

Venus, 48, *see also*
Aphrodite
Venus de Milo, *see*
Aphrodite of Melos
Vesalius, Andreas, 73–75, *145*
Vinci, Leonardo da, *28*, 28–29, *46–47*, 65, *72, 72–73, 73*
Vitruvius, 15, *28*, 131–132
Wesselmann, Tom, *119*
Whitman, Walt, 150–151
Xenophon, 45–46
X-rays, 86–87, *87, 90*
Zeus, 39, 40, 127

Photograph Credits

Text Credits

Philippe Comar, a visual artist, teaches in the Department
of Morphology of the Ecole Nationale Supérieure des
Beaux-Arts in Paris, where he also studied. His work has
been exhibited at the Centre Georges Pompidou, the Venice
Biennale, and the Cité des Sciences et de l'Industrie at
La Villette (Paris). He was co-curator of the 1993 exhibition
L'Ame au corps (*The Soul in the Body*), at the Grand Palais
in Paris, and co-editor of its catalogue.

To my daughter, Esther

Translated from the French by Dorie B. Baker and David J. Baker

For Harry N. Abrams, Inc.
Editor: Eve Sinaiko
Typographic designers: Elissa Ichiyasu, Tina Thompson
Cover designer: Dana Sloan
Text permissions: Barbara Lyons

Library of Congress Cataloging-in-Publication Data

Comar, Philippe.
 [Images du corps. English]
 Images of the body / Philippe Comar.
 p. cm. — (Discoveries)
 Includes bibliographical references and index.
 ISBN 0–8109–2858–2 (pbk.)
 1. Human figure in art. 2. Art and science. I. Title. II. Series: Discoveries
(New York, N.Y.)
 N7570.C6613 1999 99–11000
 704.9'42—dc21